A Noteworthy Americans
Quick Reader Biography Book

Eagle of Delight:

Portrait of the Plains Indian Girl
in the White House

by Jean A. Lukesh

To Paige
All the very best!
Jean A. Lukesh

Field Mouse PRODUCTIONS 2022
Grand Island/Palmer, NE

All Rights Reserved. No part of this publication may be reproduced, stored in a retrieval system, or transmitted in any form or by any means, electronic, mechanical, photocopying, recording, or otherwise, anywhere in the world without the express permission in writing from the publisher/author.

<div align="center">
Copyright © 2013 Jean A. Lukesh
Cover ©2013 by Ronald E. Lukesh
Published by Field Mouse Productions
Grand Island and Palmer, Nebraska
All rights reserved
Printed in the United States of America (2)
This Noteworthy Americans Quick Reader Biography
was designed by Jean A. Lukesh (Ed.D., Curriculum & Instruction).
Interest Level: ages 10 to 110
</div>

Lukesh, Jean A., 1950–
Eagle of Delight: Portrait of the Plains Indian Girl in the White House

SUMMARY: A quick-reading young adult biography exploring the history and mystery of the life of Eagle of Delight (Hayne Hudjihini), a teenage Otoe Indian woman from Nebraska whose portrait hangs in the White House. In 1821 she journeyed east with her husband and fifteen other Plains Indian chiefs to visit the president. There, she became one of the first Native American women ambassadors and the "Darling of Washington D.C. Society." Her 1822 portrait and four others have been on display in the White House library since 1962.

Noteworthy Americans Quick Reader Biography Series. Includes color illustrations, glossary-index, endnotes, select bibliography, and (optional) critical thinking questions and activities.

1. Eagle of Delight (Hayne Hudjihini), c1804?-1822?—Biography—Young Adult. 2. Nebraska—History. 3. Native Americans—Nebraska—Biography. 4. Native American Women—Biography. 5. Native Americans—Great Plains—Women. 6. Otoe (Oto) Indians—Biography—Women. 7. Women—Biography. 8. Nebraska—Women—Biography. 9. Native Americans—Great Plains. 10. Women's Studies. 11. Multiculturalism. 12. Minority Women.
I. Title. II. Subtitle. III. Series.
E99 970 [B] [920]
ISBN 978-0-9647586-8-1

Front cover photo: Eagle of Delight (Hayne Hudjihini), by Charles Bird King, 1822. (*Courtesy, The White House Collection*). Cover layout by Ronald E. Lukesh.

Dedication:

to the Otoe
and other First Peoples
of the Plains, to their Spirit,
Culture, and History; to my Native
American friends and those who honor
them; to my cousin Mahashka who knows
and honors all of her names; to Brit, Kenzee,
Emma, and Maddie, who are all close to Eagle
of Delight's age, with hope that they too will do
good things with their lives; to friend Ann McCord,
who helped me with 1800s ladies' fashion questions;
to our own Nebraska & the Great Plains; and to the Great Spirit for giving life, and giving us the elders to teach us how to live in this world and how to help others learn, too. This book is for them & for many, many more.

Also to special mentors, rememberers, and elders, such as Teter Morgan, Geraldine Howell, Irene Edwards, Ted Reeves, Ronnie Good Eagle, Al Kilgore, Roger Welsch, and the Echo-Hawks. To the artists Charles Bird King, Catlin, Bodmer, and others, and to other researchers, archivists, curators, and historians who have helped keep history alive, including McKenney and Hall, John C. Ewers, Herman J. Viola, and Andrew Cosentino (who all brought the stories of the delegates to light), and Gary Zaruba, George Turak, Loren McLane, Michael Miller, Riche Sorensen, Andrea Ashby, Dan Thomas, Anne Crouchley, Susie Severson, Kay Johnson, Mary Jo Schulte, Gina Garden, Jill Wicht, Lynsey Sczechowicz, Ross Matthei, and others. And to friends Gale & Peggy, the Carlsons, Ronnie O'Brien, the Boltes, Dave Scoggins, and of course, Ron and the Family.

Notes: 1. The names **Otoe** and **Missouria** are the official tribal names and were used in this book, instead of the alternate spellings **Oto** and **Missouri**. 2. Pronunciations are given in the text and in the index/glossary. 3. Tiny endnotes were used because they were considered necessary. 4. If I have made errors, I sincerely apologize, but I truly believe it is long past time to honor and remember Eagle of Delight and her noteworthy story again, in this new century. —JAL, 2013

Timeline for Eagle of Delight (Hayne Hudjihini)

1803—President Jefferson buys the Louisiana Territory from France.

1804—Lewis and Clark explore Louisiana Territory and meet the Otoe-Missouria, then go west to the Pacific; return home in 1806.

1804? (or sometime between 1803-1807)—Eagle of Delight is born.

1811-1812—The Madrid Earthquake causes "Great Shaking" up the rivers, across the Great Plains, and into the Eastern United States.

1819-1820—Major Stephen Long and his men visit the Otoe-Missouria and write about Prairie Wolf and other chiefs; Eagle of Delight probably receives her "mark of honor" around this time.

1820?—Eagle of Delight becomes the fifth wife of Prairie Wolf (Shaumonekusse, Yutan, or Ietan), sub-chief of the Otoe.

1821, Fall—Eagle of Delight travels east with her husband and other Plains Indian chiefs to Washington D.C. and other cities. There she becomes "The Darling of Washington D.C. Society."

1822, January 1—The 1821-1822 Plains Indian delegates meet the president and attend the New Year's Dance at the White House.

1822, February—Eagle of Delight speaks to President Monroe; Portraits of her and other delegates are painted by artist Charles Bird King and put on display in McKenney's office and elsewhere.

1822, March—Eagle of Delight and the other Plains Indian delegates start home to their villages west of the Missouri River.

1822?—Eagle of Delight dies shortly after returning home to her village.

1826—A portrait of Eagle of Delight and portraits of four other 1821-1822 delegates are sent to the Netherlands.

1830s—Eagle of Delight's portrait is one of eight Native American women in the McKenney-Hall books of Indian Portraits; an Iowa chief sends Prairie Wolf a copy of Eagle of Delight's portrait.

1962—First Lady Jacqueline Kennedy receives portraits of Eagle of Delight and four others for her White House project. In the 1960s, historians begin again to write about the delegates and the portraits.

Table of Contents

Chapter 1: Introduction to Eagle of Delight	1
Chapter 2: Piecing History Together	3
Chapter 3: How the Otoe Came to Nebraska	6
Chapter 4: At Home on the Nebraska Plains	13
Chapter 5: Beloved Child	17
Chapter 6: Clan Names	19
Chapter 7: Other Kinds of Names	24
Chapter 8: Louisiana Territory	27
Chapter 9: Lewis and Clark Meet the Otoe	33
Chapter 10: Growing Up Otoe	37
Chapter 11: The River Monster	42
Chapter 12: Major Long and the Otoe	47
Chapter 13: Otoe Councils Near the Bluff	50
Chapter 14: The Sun Between Her Eyes	54
Chapter 15: The Man Painted Black	60
Chapter 16: Bride Price	64
Chapter 17: A Change of Plans	69
Chapter 18: Special Invitation	73
Chapter 19: Speaking for Mother Earth	79
Chapter 20: Leaving Home	83
Chapter 21: The Journey Begins	86
Chapter 22: East Meets West	91
Chapter 23: Tours and Admirers	97
Chapter 24: The Darling of Washington Society	105
Chapter 25: The Last White House Welcome	111
Chapter 26: The Words of a Woman	114
Chapter 27: Picturing the Plains Indians	120
Chapter 28: End of the Trail	127
Chapter 29: Inspiring Others	132
Chapter 30: Moving Away From the Homeland	137
Chapter 31: Eagle of Delight's Place in History	141
Thinking Activities: About Eagle of Delight	144
Endnotes	146
Bibliography	148
Glossary and Index	150

Eagle of Delight, or Hayne Hudjihini
(pronounced Hay-nuh Hoo-djuh-hee-nee)
portrait by Charles Bird King, 1822.
(*Courtesy, The White House Collection*)

Chapter 1

Introduction to Eagle of Delight

If someone asked you to name the most important early Native American women in history, who would you list?

Would you name Pocahontas who saved John Smith and the Virginia colony in the 1600s?

Would you list Sacagawea who helped guide Lewis and Clark in 1804 and 1805?

What about Susette LaFlesche Tibbles, the Omaha Indian woman who spoke for Chief Standing Bear of the Ponca at his trial in 1879?

Or Susette's sister Susan LaFlesche Picotte, the first Native American woman medical doctor?

Those are all great choices. But you might also list Eagle of Delight, a teenage Otoe Indian girl, often called Hayne Hudjihini (Hay-nuh Hoo-djuh-hee-nee). Her 1822 portrait is in the White House. Copies of

that portrait can be seen in books, posters, art rooms, and museum collections around the world.

Many people have seen Eagle of Delight's face, but few people, today, know any of her names. Almost no one remembers who she was, where she grew up, or why she was important.

To most, she is just the face of an unknown Native American woman—a girl of history and mystery—almost forgotten over time.

But in 1821-1822, Eagle of Delight became very famous, on the plains, in the East, and even in Europe. During that time, that teenage girl and sixteen Plains Indian chiefs made a historic journey of more than 1,400 miles to visit the White House.

There, she became one of the first and youngest Plains Indian women to represent her people in the East, and was one of the first to have her portrait painted. She became famous as "The Darling of Washington D.C. Society." And there, her portrait has long been on display in the White House.

This book uncovers, rediscovers, and explores the history and mystery of Eagle of Delight of the Otoe people and her short but remarkable life.

Chapter 2
Piecing History Together

Eagle of Delight's early life is still a mystery. However, we do know some things about early America, her Otoe people, and her visit to the East.

By using that information, we can begin to piece together her life history. We can also begin to make some good guesses about her.

Much of her story has been lost for a long time, so we also need to know one more thing: No matter how much we discover about Eagle of Delight, we may always have unanswered questions about her.

Starting With What We Think We Know

To begin to learn more about Eagle of Delight as a real person, we first need to look at what we think we know about her and her people.

Easterners who met her in 1821-1822 said she was a member of the Otoe tribe. They said she was

between 15 and 18 years old at that time.[1] So she was probably born sometime between 1803 and 1807.

The white people's dates of 1803 and 1807 did not mean much to the Plains Indians then. Native Americans did not use a written language of words and numbers. They did not have paper records of births and deaths that could be filed and checked.

Instead of calendars or written records, Native Americans made picture charts on hides. They also memorized and drew "winter counts" of special events for themselves and their tribe.[2]

To make and keep a winter count, a person memorized a list of one important thing that happened in each year of their life. For example, their first winter count might have been "the winter when (or after) I was born." Their second might have been "the winter I learned to walk." Other counts would have followed for each year.

If we had known Eagle of Delight's winter counts, we could have used those to help figure out when she was born and other things about her.

Rememberers

Tribal history was also passed along by family

members or elders. Elders were respected people who had knowledge or skills that helped the tribe survive.

Some elders were called rememberers. They were trained from an early age to memorize important things about their culture.

Some elders retold family and tribal histories in the form of stories. They passed down knowledge to others, so important things would not be forgotten. Such storytelling and oral history worked well. It entertained people and helped keep history alive.

Even so, knowledge was sometimes lost over the years if no one told the stories or if a rememberer died. Such a loss could cause gaps in the history.

We hope that modern Otoe elders still know a lot about Eagle of Delight. They may know the names of her parents and brothers or sisters. They may know when she was born and a lot more.

If so, that information may someday be available. But for now, we have to use whatever information we can find, to try to uncover and rediscover her history.

Chapter 3
How the Otoe Came to Nebraska

When Eagle of Delight was born, her Otoe people were Plains Indians. They were farmers and buffalo hunters living in what is now Nebraska. But her people had not always lived there or in that way.

Where did her people come from? Why did they move to the plains of Nebraska? What did their stories say?

As Eagle of Delight was growing up, she may have heard the following stories about her ancestors, the people of her tribe who lived before her.

Wandering Tribes

History stories say the early Otoe and three related groups once lived around the Great Lakes near Canada. There, they shared a similar culture and past. They may have had other names then, but by the time Eagle of Delight was born, those groups were

called the Otoe (Oto), Missouria (Missouri), Iowa (or Ioway), and Winnebago (or Ho-Chunk) people.[3]

All those people first lived as hunters, gatherers, and fishermen. Fishing provided their main meat supply in the early days, but they often had to wander far to find other wild foods.

Some time, long ago, those people moved further south of the Great Lakes. There, the Winnebago group found a place they liked. They settled down. The other groups may have stayed there for a while, too.

Then after a time, those other groups wandered off, toward the south and west. They may have been searching for food or warmer weather. They may have been moving away from hostile tribes or from sicknesses brought by explorers or traders.

A Changing Lifestyle

Living on the warmer, drier grasslands, those groups found that their food supply was different. So their way of life had to change, too. The men began to spend more time hunting grassland animals and less time fishing. The women gathered more kinds of plants. They began to garden and to farm.

This map shows how early Otoe, Missouria, and other related groups may have come from the Great Lakes onto the grasslands of what became the United States. It also shows how the Otoe and Missouria came to live at Yutan Village in Nebraska. (*Map by Ron Lukesh*)

Splitting Up

As those groups wandered, they moved further away from each other. They were trying to find the best place for their own people to live.

On the grasslands of Iowa, the "Gray Snow People" (or Iowa tribe) found an area they liked.[4] There the women built earthlodge homes and villages with the help of some of the men. The women planted gardens, and the men hunted.

For a while, the Otoe and Missouria people lived near their Iowa friends and relatives. Later, they left the Iowa people and headed west together.

Then somewhere along the Missouri River, a big argument arose between the Otoe and the Missouria. That terrible argument split those two friendly tribes apart and sent them off in different directions.

What could have caused such a big problem between those two tribes who had long been friends?

A Lovers' Quarrel

One day, a young Otoe man fell in love with the daughter of a Missouria chief. Their names may have been lost over time, but their story is still well remembered in the legends of those two groups.[5]

The young couple wanted to marry. But in those days, marriages were often arranged by the families and were not usually based on love.[6] There were other important things to consider, for the good of both tribes and all the people.

For whatever reasons, the girl's father and the elders would not agree to the marriage. So the two young people ran away to be together. When they returned to the village, they did not move in with the bride's family, as was expected. Instead, they moved in with the young man's Otoe people.

By doing that, the lovers broke several customs. That made the Missouria girl's family sad and angry. And that led to other problems between the two tribes and families.

For those reasons, the people of the Otoe and the Missouria decided they could no longer live together. They split up the two villages to keep their people from going to war against their neighbors and friends.

A Change in Name

The Otoe were sometimes called Chiwere (Chee-WEH-ray) or "People of This Place." But after the argument, the Missouria people nicknamed them

"the Otoe." That name may have been part of a longer Missouria word. That word meant the two young people had broken tribal rules and customs.[7]

Splitting Apart

To avoid even more trouble, the girl's father then led his Missouria people away from the Otoe village. He took them toward the southeast. They traveled along the Missouri River. (The name Missouria may mean "People Who Live Along the River.")[8]

Instead of following after their former friends and relatives, the Otoe people and the young couple chose to head west. After crossing the Missouri River, they moved out onto the Great Plains.

There, in what is now eastern Nebraska, the Otoe people finally found an area they liked. At that place, they built a permanent settlement. That new village was about 35 miles west of the Missouri River and just a few miles from the Platte River. That site would later become known as Yutan (YOO-tan) Village.

Eagle of Delight was probably born there.

THE YUTAN OTO INDIAN VILLAGE

Spanish colonial correspondence from 1777 noting the presence of an Oto Indian village on the Platte likely refers to the Yutan site, named after the Chief Iatan. Yutan would have been the first Indian settlement seen by fur trappers and military expeditions traveling up the Platte Valley to the Rocky Mountains. In 1833 the village was the site of a treaty between the Oto, Pawnee, and Delaware, and in 1835 the Oto abandoned the site. Two decades later, the reservation period began for the tribe.

Yutan Village of the Otoe (Oto) People

This Nebraska State Historical Society marker stands along Highway 92, near the town of Yutan, Nebraska, about 30 miles west of Omaha and about 35 miles west of the Missouri River (*Photo by Ron Lukesh*)

The old Yutan village site was located in or near today's town of the same name. That long-abandoned village site is probably where Eagle of Delight was born and where she lived most of her life.

At some time, that village was named Yutan for Eagle of Delight's husband Prairie Wolf who was a head chief of the Otoe in the later 1820s and 1830s. The names Yutan, Iotan, Iatan, Shaumonekusse, Chonemonicase, and "The Comanche" were just some of Prairie Wolf's many names.

Chapter 4
At Home on the Nebraska Plains

The Platte River was wide and shallow near Yutan Village. The river was so shallow at times that the French fur traders called it the "Flat Water" or the Platte River. (The French word for flat was "platte." The words flat and platte even rhymed.)

But the Otoe did not call that river the Platte. They called it "Ne-brath-ga" or "Ne-brath-ka." That word meant "Flat Water" too, in the Otoe language.[9]

Soon other people began using the word Ne-brath-ka to mean not just the Platte River, but also the flat lowland areas around the river. That is how the state of Nebraska got its name—from that Otoe word for the river they called "Flat Water."

Banding Together Again

Some time after the Otoe settled near Yutan Village in Nebraska, the Missouria tribe also drifted

west onto the Great Plains. There, they found the Otoe already settled.

Both tribes had lost many of their people to smallpox and other new diseases by then. The Otoe group was more than twice as large in number as the Missouria. But both groups were much smaller than most of the neighboring tribes. That made both the Otoe and the Missouria easy targets for larger or more hostile groups on the plains.[10]

For their own safety, the Otoe and Missouria people banded together and became friends again. They made their homes near each other for safety, just as they had done before. Together, they could protect each other. Together, they could survive.

The old argument between them was over, but not forgotten. It would always be part of their history.

That new name Otoe had become acceptable to both groups. Together they became the Otoe-Missouria (or the Otoe and Missouria) people of Yutan Village.

Becoming Plains Indians

At Yutan, the Otoe and Missouria lived as Plains Indians, much like their Pawnee and Omaha

neighbors. They built and lived in large dome-shaped earthlodges covered with dirt and sod grasses.

The Otoe people lived in their earthlodge village for most of the spring and fall of each year. During those two seasons, the women farmed their fields nearby. They planted and harvested crops of corn, beans, squash, pumpkins, and watermelons. The men often hunted deer, elk, and other game animals.

Twice a year, the whole tribe traveled west to find and hunt buffalo. While on the trail, they often lived in tipis (or teepees) made of buffalo hides. Tipis made excellent temporary homes when the people were hunting, trading, or visiting relatives, such as the Iowa people who lived east of the Missouri River.

Home to Many Tribes

Many Plains Indian people called Nebraska their home in the early 1800s. In addition to the Otoe and Missouria tribes, other farming people also claimed parts of the area. They included the Omaha, the Ponca, the four bands of the Pawnee, and sometimes the Kansa (also known as Kaw or Konza).

Conflicts

That area was also the hunting land of some

nomadic Plains Indian people. They included the Cheyenne, Arapaho, and Sioux (now often called the Lakota). Those people did not live in earthlodge villages. They lived in tipis and moved often throughout the year.

They were hunters and gatherers who traveled far across the plains. They did not farm or grow their own crops. Instead, they hunted most of the year. Sometimes they raided the fields or storage areas of the farming tribes.

The nomadic tribes and the farming tribes all depended upon the same food and water resources on those hunting lands. That caused a lot of conflict. Sometimes they lived in peace, but often the tribes were at war with their neighbors.

Into that world, Eagle of Delight was born.

Chapter 5
Beloved Child

Eagle of Delight's Otoe-Missouria people were probably living at Yutan Village when she was born in the early 1800s.

At that time, Eagle of Delight's mother may have left the earthlodge she shared with her husband and family. She may have moved into a separate tipi or a small lodge nearby, to wait for her child to be born.

The birth of a baby was a time of celebration. Otoe babies were truly loved by their parents. Some children were even named "Beloved Child."[11]

Taking Care of Baby

After the baby was born, she was cleaned, rubbed with animal fat to soften and protect her skin, and wrapped in soft furs. She was held and fed, and her diaper rags were changed.

Then her mother put her into a baby carrier called a cradleboard. That cradleboard would have been new, or one that had been lucky for the family. The heavy rawhide leather protected and held the baby safely. The inside was well padded with soft milkweed fluff or furs.

Sometimes the mother carried her baby and talked or sang to her. Sometimes, she hung the cradleboard from a lodge pole or a tree branch, so the breeze could gently rock her child to sleep. At other times, the mother strapped the cradleboard to her own back, so her hands were free to work. Warm and safe inside, the baby napped or watched what was going on around her.

What to Name the Child

Mother and baby stayed in that lodge for several days. During that time, the father spent most of his time preparing to celebrate the birth of his child in the Otoe way of the 1800s.[12] He often hunted, made presents, and thought about what to name his child.

Finding the right name was important. In the early 1800s, a baby's name was usually chosen from a list of names used by the father's clan.

Chapter 6
Clan Names

A clan is a family group. Otoe children were usually members of the same clan as their father. Each clan had its own names, traditions, leaders, roles, customs, beliefs, and place within the tribe.[13]

Names were important. They helped Otoe people keep track of each other. Names even showed clan relationships, such as how people were related and other important things.

Clan Animals

Among the Otoe and many other Native American tribes, clans were often named after a special animal. Eagle of Delight's Otoe people had eight clans in the 1800s: the Bear, Beaver, Buffalo, Eagle, Elk, Owl, Pigeon, and Snake clans. There may have been a Coyote or Wolf clan, too. The Coyote, Wolf, and Snake clans may no longer exist.[14]

Following Ceremony

The Otoe-Missouria people had many ceremonies. Steps needed to be followed to be sure things were done correctly and at the right time.

When Eagle of Delight was four days old, her family probably held one of the first of several childhood ceremonies—the actual naming of the baby. At that time, her father probably held a feast for the people of his tribe. He provided food and gave away horses and other gifts in honor of his baby.[15] Then the father announced the name he had chosen for his child.

Announcing the Name

When Eagle of Delight's father announced the name of his new baby, that name told the people the following four things: 1. the baby's clan, 2. the father's clan, 3. the child's birth order in the family, and 4. the child's gender (whether the child was a boy or a girl).

How could the people of the tribe know all that from just the new baby's name?

Clues to the Baby's Name

Traditional Otoe baby names often contained

some word relating to their clan's animal or a related animal, or actions or features common to that animal. For example, many eagle clan names contained words such as eagle, hawk, diving, soaring, circling the earth, or other terms related to a bird of prey.

Any of those words used in a name were clues that the child and its father might be members of the eagle clan.

We do not know a lot about Eagle of Delight's early life or if that was even her baby name. But we do know that some people called her Eagle of Delight and others called her Little Eagle.[16]

So from those eagle-related names, we can make a good guess that she and her father may both have been members of the eagle clan.

Charting the Baby's Birth Order

Many of the traditional names within a clan also showed the child's birth order in the family. Some clan names were used only for a father's first-born child. Others were used only for his second-born child. Still others were used only for his third-born child, or fourth-born child. There were also names that could be used for other later-born children.

Names That Told Gender

Many traditional Otoe baby names were appropriate for either a boy or a girl in those days, but a few names were only given to boys.

If an Otoe name could be used for either a boy or a girl, then the girl's name was usually just a little bit different from the boy's name. (That is common in other cultures, too, as with such names as Eric and Erica, or Terry and Terri, or Samuel and Samantha.)

Checking the Chart

Look at the Eagle Clan Naming Chart on the next page. Can it tell us anything about Eagle of Delight?

Eagle of Delight is not one of the traditional names listed, but that chart may not be complete, or her name could have been translated wrong.

Eagle of Delight had other names. too. Notice that Little Eagle—another of her names—is listed on the chart as a name for either a fourth-born boy or girl of the Eagle Clan. If that name was indeed her real given or baby name, she may have had three older brothers or sisters.

We will probably never know for sure.

Eagle Clan Naming Chart

This is a chart of some traditional translated Eagle clan names once used by the Otoe people.[17]

If you had been a member of the Otoe eagle clan, what might your name have been? Why?

Birth Order	Boys' Names	Girls' Names
1st Born	True Hawk Standing on the Earth Soaring High Circling Around the Eagle's Nest Eagle King Good Eagle True Eagle	True Hawk Standing on the Earth Circling Around the Eagle's Nest Eagle King Good Eagle True Eagle
2nd Born	True Feather Good Feather from Eagle's Tail Striking /Diving After Prey	True Feather Good Feather from Eagle's Tail
3rd Born	Black Hawk Landing on a Tree Red Eagle	 Landing on a Tree Red Eagle
4th Born	Iron Hawk Little Eagle	Iron Hawk Little Eagle
Other Eagle Names	Big Wing Short Wing Little Thunder	Big Wing Short Wing

Chapter 7
Other Kinds of Names

In the early 1800s, the names of most Otoe-Missouria children came from a clan list. But people also received names in other ways.

Names of Honor

Instead of clan names, Otoe families sometimes passed down the names of greatly loved, respected, or successful people. So they might re-use the name of a special or well-known elder or other person.

As children grew older, they could also have additional names. Plains Indian men often gave themselves new names in honor of an important deed, especially in war or in hunting. Women had fewer chances to earn honors, so they may have had fewer names and name changes.

Nickname Names

People could have baby names, honor names,

and even nicknames, too. Nicknames could point out a special quality or feature of a person. Or those names could come from dreams or wishes or things that happened to that person.

Kinship Names and Customs

In addition to other names, Plains Indian people also called each other by kinship terms. Those are words that show how people are related, such as mother, father, sister, brother, uncle, or other terms.

In the Otoe language, a kinship name sometimes told which side of the family the person was on. For example, an aunt might be called "my father's sister" in the Otoe language. Some aunts and uncles were so close that they could even be called "mother" or "father." Kinship names could also be given to non-related people who were treated as family members.

However, some family members were not supposed to speak to each other. To keep the peace, a man and his mother-in-law were not to talk to or about each other. But a man could speak to his father-in-law, if the subject was important.[18]

Not So Simple

The Otoe language was not simple either. Men

and boys often used slightly different-sounding names and words than the ones used by women and girls to say the same things. People who grew up in the tribe learned those customs early and easily. But problems arose, when other cultures were involved.

Name Changes Due to Translations

In the early 1800s, Eagle of Delight and other Native Americans spoke their names. Sometimes they drew their names in pictures, but they did not write them down in words.

When other people heard those names, they sometimes tried to write them down—just the way the words sounded. But words and sounds do not always translate well to people of other cultures.

Then too, not everybody hears, understands, or writes things the same way or in the same language. As a result, many Native American names have been shortened, mistranslated, or written with different spellings or meanings.

All of that makes it even more confusing and difficult to try to research the history of Native American people, such as Eagle of Delight.[19]

Chapter 8
Louisiana Territory

We may not know much about Eagle of Delight's family, her baby name, or her birth date. But we do know she was born in the very early 1800s.

We also know that Napoleon Bonaparte, the leader of France, claimed most of the Great Plains at that time. He called that area the Louisiana Territory.

That Louisiana Territory stretched all the way from Canada to the Gulf of Mexico, and from the Mississippi River west into the Rocky Mountains. That huge area included the land that is now Nebraska, where the Otoe and Missouria then lived.

In 1803, Napoleon needed money, so he sold all that land to President Thomas Jefferson of the United States. That sale was called the Louisiana Purchase.

EAGLE OF DELIGHT 28

What Did President Jefferson Buy?

When President Jefferson bought that huge Louisiana Territory, he doubled the size of his own eastern United States. (At that time, the far western 1/3 of North America was claimed by other foreign countries, including Russia, England, and Spain).

But Jefferson did not really know what he had bought. He did not know how big that Louisiana Territory was or who or what people lived there. He did not know what animals were there, or what the land looked like, or how it could be used. He did not even know how far west that land stretched, or if it went all the way to the ocean.

The president needed answers. So he ordered two military men—Meriwether Lewis and William Clark—to go up the Missouri River to explore that land and meet the people living there.

The Journey of Discovery Begins

In the summer of 1804, Lewis and Clark and their men came up the Missouri River by boat. Sometimes, they explored the eastern or Iowa side of the river. At other times, they came across to the western or Nebraska side.

Meriwether Lewis, portrait by Charles Willson Peale, from life, 1808. (*Courtesy, Independence National Historical Park*)

As they traveled, Lewis and Clark explored as much of that huge Louisiana Territory as they could. They and their men—artists, writers, scientists, and soldiers—made notes, reports, drawings, and maps of what they saw and the people they met there.

They drew and collected samples of the new and strange things they found, and they sent many things

back to the president. They even sent him a live prairie dog and other animals and plants that Easterners had never seen before.

Planning to Meet the Otoe

Lewis and Clark wanted to meet the people of the plains, including the Otoe. The explorers already knew some things about the Otoe and Missouria people even before they met them. They knew from nearby fur traders and trappers that those people lived near the Missouri and Platte Rivers.

They also knew that the Otoe tribe had only about 500 people, including around 125 warriors. The Missouria had about 300 people and 85 warriors.[20]

The Otoe leaders were often the more forceful of the two tribes. So the explorers often called that whole group the Otoe, instead of the Otoe-Missouria. In their journals, Lewis and Clark sometimes wrote the name Otoe as "Oto" or "Otto" or "Ottoe."

The explorers sent men to call the leaders of that tribal group to a council or meeting. But at that time of the year, the Plains Indians were away from their villages. They were out west hunting buffalo.[21]

So Lewis and Clark sent messengers to invite

the Otoe and the Pawnee groups to come upriver and meet them later, after the buffalo hunts were over.

The Council Bluff

While they waited for the Plains Indians, the explorers moved farther up the Missouri River. There they set up camp at a high, flat-topped hill where they planned to hold their meetings. They called it the Council Bluff. Their reports recommended that a fort should be built there sometime in the future.

That Council Bluff was on the west or Nebraska side of the river.[22] (The city of Council Bluffs, in Iowa, was built much later and across the river to the east.)

Chapter 9
Lewis and Clark Meet the Otoe

The Otoe called August the "moon when the elk whistle." In that month in 1804, the Otoe returned from their buffalo hunt. Then their chiefs went to meet Lewis and Clark at the Council Bluff.[23]

The two head chiefs of the Otoe-Missouria then were Big Horse (or Shongo Tonga) and another chief that the fur traders called Voleur (Vo-LURE). In French, that name Voleur meant The Thief or Little Thief. But translations can be wrong or misleading. Voleur was no thief. He was a great hunter, warrior, and leader of the Otoe people.

Other Otoe-Missouria and Iowa leaders at those meetings included White Horse, Hospitality, Crow's Head, Black Cat, Iron Eyes, Big Axe (or Big Ox), (Great) Big Blue Eyes, and Brave Man.[24] One of those men may have been Eagle of Delight's father.

At the meetings, Lewis and Clark told the Otoe that President Jefferson now owned their land. They said the president wanted the Native Americans to be friendly to all Americans and to other Plains Indians.

The Otoe-Missouria did not like or understand everything the explorers said, but they agreed to try to be friendly. For that, their leaders received gifts.

Jefferson Peace Medal (front). (*From the author's collection*)

Peace Talks

To prove their friendship, Lewis and Clark handed out American flags and peace medals to the

Plains Indian leaders. One side of the medals showed a picture of President Jefferson. The other side showed two hands clasped together in friendship. Those medals came in three sizes.

Jefferson Peace Medal (back). (*From the author's collection*)

At the meetings, the men shared food and traded gifts. They made speeches, smoked peace pipes, and made promises of friendship. Otoe leaders were also encouraged to visit the president in the East.[25]

Then the Otoe returned to their village, and the explorers continued their journey. Later, the

explorers met a French trader and his young Shoshone Indian wife. Her name was Sacagawea. She led the men across the mountains to her own people. The explorers traveled on to the far northwest where they spent the winter before starting home.

The Otoe Head East

In 1805, some Otoe and other Plains leaders started east to visit the president. Along the way, some of them became ill with the white men's diseases, and chief Voleur or Little Thief of the Otoe died. Some of the chiefs turned around, but a few met President Jefferson before returning home.[26]

Lewis and Clark Return

In 1806, Lewis and Clark and their men also returned to the East. They told President Jefferson that some Native Americans had promised peace and friendship—but others had been less friendly.

New Beginnings

Eagle of Delight may have been a baby when Lewis and Clark gave her people peace medals. Years later, she would journey east to meet a new president named James Monroe. There she would talk to him about his peace medals.

Chapter 10
Growing Up Otoe

As a young child, Eagle of Delight probably played with other Otoe-Missouria boys and girls—running foot races, riding ponies, and learning the ways of her people.[27]

Childhood was a happy time. Otoe children had a lot of freedom and were seldom spanked when they did wrong. Instead, they were encouraged to do good things and to be good role models for others.

The women and old people watched over all the children of the tribe—not just their own family. The adults made sure all the children were happy, well fed, and protected.

Growing Up Differently

As Eagle of Delight and the other children grew, they began to spend their time in different ways. Young boys went with older boys or men to learn

important survival skills. They learned the ways of the hunters and warriors. Boys also took care of their father's belongings, including their pony herds.

Girls learned to take care of things in the homes and fields. They prepared to become wives and mothers. Little girls played with homemade dolls. Older girls helped cook, clean, and care for children.

Young women learned about preparing hides and making clothes, robes, blankets, and tipi covers. They learned to make household tools from antlers, buffalo horns, and animal bones. They also learned to build earthlodges and tipis. They carried water from the river and learned about farming and crops.

Learning From the Elders

In the early 1800s, Otoe children did not go to school like white children did. Instead, they received important teachings or lessons from family members and elders.[28] Those teachings showed the children what was proper and what was expected of them.

Everyone was expected to follow the teachings. Some of the most important lessons said that all people were to behave, to treat others with respect, and to follow the rules and customs of the tribe.[29] If

everyone did that, then there would be fewer problems in the village. There were other teachings and expectations, too.

Common Expectations

Each family was responsible for the behavior of its children. Families were judged on the way their members acted and the things they did. No one wanted to be ashamed of the people in their family. Good behavior was strongly encouraged.

Expectations for Boys

Boys usually received more teachings than girls.[30] Through those teachings, boys were encouraged to become wise and good leaders—chiefs, warriors, doctors, or priests. They were encouraged to be good fathers, uncles, and grandfathers. A boy's best friend and role model was often his mother's brother.

From their lessons, boys learned what was expected of them as men. They were expected to be good hunters, providers, and husbands. They were to help the poor, the orphans, and the old people of their tribe. They were also expected to work hard, to earn honors, and to respect themselves and others.

Expectations for Girls

Girls also received teachings. Their lessons taught them about their place in the tribe—and at that time, their place was usually far more limited than that of the boys.[31]

Otoe girls were taught early about what they could and could not do. They were taught never to walk in front of a man. They were taught to always sit in their own spot in the lodge. They were expected to be quiet and to obey the elders and also their father and their husband. They were taught to do only honorable things.

Girls were taught to work hard in and around the home. They were expected to become wives and mothers, not usually chiefs or leaders. Girls, in those days, were seldom involved in the tribal government. But as women, they had a lot of power and control over their children, homes, fields, and food supplies.

A few women had even more power. That power was because of their father or husband—and because of a very special mark of honor that certain women received. Eagle of Delight would be one of those women.

Becoming Adults

At different times in their lives, Otoe boys and girls also went through special ceremonies to prepare them to become adults. They were expected to grow up, marry, become parents, and raise their own children in the same way they had been raised.

Among the Otoe, all girls were expected to marry. Some girls were even married around the age of 14 or 15. That was a part of the culture of their people then.

Life was very difficult in those days, and people did not live very long. Children needed to be ready to grow up quickly, to take on the role of an adult early in life. That was how the tribe survived.

That was how Eagle of Delight grew up and lived.

Chapter 11
The River Monster

When Eagle of Delight was a little girl, she and her Otoe people may have felt the great shaking of the earth during the winter of 1811-1812.[32] That was the time of the New Madrid (MAD-rid) earthquake. During the bigger shakings, some rivers even seemed to flow backwards for a short time. How frightening that must have seemed to the native people!

Years later, in 1819, Eagle of Delight probably heard about four strange-looking boats that came up the Missouri River. They were a new kind of boat called a steamboat or a riverboat. The air around those boats was full of gray-black smoke and steam.

The steamboats were huge, and each one seemed to move upriver all by itself—with little or no help from the men who walked around on its back.

Those riverboats brought an army of American

soldiers and explorers to meet or hold councils with Eagle of Delight's Otoe people. That army was led by Colonel Henry Atkinson and Major Stephen Long. Those two officers brought scientists, artists, doctors, writers, and over a thousand soldiers with rifles, cannons, and other guns. They even brought a military band that could march while playing music.

Long's Dragon

One of the four riverboats came further north up the Missouri River. That boat looked a bit different and a lot more frightening than the other three. It was painted red and black—colors that symbolized power and strength to many Plains Indians.

That boat was called *The Western Engineer*. It looked a little like a river monster or a dragon with a ship on its back. Major Long had designed it, so people also called it *Long's Dragon*.

Long's Dragon whistled and blew steam from something that looked like the tiny head of a snake or a dragon at the front of the steamboat. The dragon seemed to blow fire and smoke or steam from a tall smokestack on its back.

Long's Dragon sat high in the water. It was the

first steamboat able to come that far up the Missouri River. The strange noisy boat frightened the Plains Indians. Most of them had never seen any steam-powered machines before. They had never seen a boat that moved by itself and looked and sounded like a river monster.

The Western Engineer (Steamboat or Riverboat), drawn by Titian Ramsey Peale [who was with the Stephen Long Expedition], 1819. (*Courtesy, The American Philosophical Society, Philadelphia, PA*) *The Western Engineer* was also called *Long's Dragon*. Note the tiny snake-like head and steam rising above the water to the right.

Steamboats in the Sand

Steamboats were a new idea at that time. But the Missouri River was often too shallow and full of tree snags and sand bars for most of those boats. *Long's Dragon* handled the river better than the others, but

even it had trouble in the sandy water.

The three other steamboats that had started up the river with it often were stuck in the sand along the way. The men had to leave those boats downriver. They had to walk along the shore or come upriver on smaller boats to set up the army camps further north.

Setting Up Two Camps

Colonel Atkinson and Major Long set up one camp along the river just north of Manuel Lisa's fur trade post of Fort Lisa. That was near today's city of Bellevue, Nebraska, on the Missouri River.

The men called that first new camp Engineer Cantonment. (Cantonment is another name for a military camp.) That camp was about five miles below Nebraska's Council Bluff, where Lewis and Clark had met the Otoe-Missouria.

Other soldiers from Long's army also went upriver. They made a second camp along the riverbank about six miles further north. That was about a mile north of Nebraska's Council Bluff. They called that second place Cantonment Missouri.

The men quickly cut trees and built cabins at those camps. Winter was coming. They would need

good shelter and lots of food, supplies, and firewood to survive.

But they soon discovered that the area around the northern camp was too low and too close to the river. Bad weather, flooding, mosquitoes, and sicknesses caused problems there. During that first winter, about 160 men would die. Many more would be very ill.

Moving to a New Site

Before long, that northern camp (Cantonment Missouri) had to be abandoned. Colonel Atkinson then had his men move to higher ground near the (Nebraska) Council Bluff, a mile or so away.

There on that high ground, the soldiers began building a new fort, just like Lewis and Clark had suggested in their reports. That fort would be named Fort Atkinson, for Colonel Henry Atkinson.

Fort Atkinson would be the first fort west of the Missouri River—and the first fort on the road to the Yellowstone River and the fur trade further west.

Eagle of Delight's future husband would later visit that fort to trade and sign peace treaties there.

Chapter 12
Major Long and the Otoe

While Fort Atkinson was being built, Major Long sent men to find the Otoe and the Pawnee. Those Plains Indians were invited, but they were also told to send their leaders to meet Long at the Council Bluff on the west bank of the Missouri River.

Inspiring Fear

Many Plains Indian leaders came to those council meetings in 1819 and the next year. They and their horses were scared of the strange things they heard and saw there. They were especially afraid of the monster-like riverboat called *Long's Dragon.*

They were afraid of other new things too, including the strange loud metal things the white men used to make music. They also feared the long rifles, smoky black gunpowder, and the huge army of men.

Major Long's army brought large guns, too,

called cannons. At certain times of the day and night, the men shot off those weapons. Like the strange riverboat, those big guns belched and roared, filling the air with smoke and loud noises.

The big guns sent cannon balls and pieces of metal flying across the land. The cannon balls whistled or screeched as they flew through the air and crashed through tree branches. Those pieces of metal splintered rocks and trees. Dirt flew, and big holes suddenly appeared in the ground.

Many of the Plains Indians were still using bows and arrows at that time. Some of them had long rifles and metal knives. But most had never before seen such a new and scary collection of weapons, ammunition, tools, musical instruments, and steam-powered boats that seemed to move by themselves.

The Native Americans tried hard not to show it, but they were very afraid. And that was just what Major Long wanted.

To Keep the Peace

Major Long wanted the Plains Indians to see how powerful the white men's weapons were. He wanted to scare the Native Americans into making

promises of peace and friendship—to each other, and to all Americans.

The United States did not want war with the Plains Indians. By the early 1800s, Americans had already fought several wars back East. Those wars were against soldiers from other countries and also against some Eastern Indian tribes. America did not want war in the West or with the Western tribes.

Major Long's show of strength and power was meant to keep more wars from happening. Major Long and Colonel Atkinson wanted the plains to be peaceful. So did the new president of the United States.

Chapter 13
Otoe Councils Near the Bluff

During those meetings in 1819 and 1820, white men and Plains Indian leaders met. They traded gifts and talked about peace. Again, the white men gave peace medals to the chiefs. This time, the medals did not show the face of President Jefferson. Instead, they showed the face of a new president, James Monroe.

William Clark's Nephews

At those meetings, Major Long had help from an Indian agent known as Major Benjamin O'Fallon. (Indian agents were often called "Major" even if they had never served in the military.)

Major O'Fallon was the nephew of William Clark, of the 1804 Lewis and Clark Expedition. In 1819, Clark was living in St. Louis. He was in charge of many Plains Indian tribes in the old Louisiana

Territory. He was also in charge of the Indian agents for those Native Americans.

Clark had made one of his nephews, John O'Fallon, the trader at Fort Atkinson. Clark had made John's younger brother, Benjamin O'Fallon, the agent for fourteen Plains Indian tribes. Those tribes lived in the area of the upper (or northern) Missouri River. They included the Otoe-Missouria, Pawnee, Omaha, Kansa, and some other tribes.

William Clark had met some of the Otoe leaders at his own meetings at the Council Bluff in 1804. He may even have met Eagle of Delight's father and her future husband. In 1819, Clark's nephews met Otoe and Pawnee leaders at the same place.

At the 1819 and 1820 talks, Major Long and Major Benjamin O'Fallon told the Plains Indians many things and asked them questions, as well. Some of the trappers and traders translated for them.

Picturing the Council Meetings

Major Long's artists drew pictures of the meetings. An artist named Samuel Seymour was at the Otoe Council of October 4, 1819. He drew and painted an artwork that he called *The Oto Council*.

EAGLE OF DELIGHT 52

The Oto (Otoe) Council, by Samuel Seymour, 1819. (*Courtesy, Drexel University, Philadelphia, PA, ANSP Collection 79, Vol. 1, Plate 25a*) Stephen Long's meeting with the Otoe, Missouria, and Iowa leaders at Council Bluff (Nebraska) was drawn and painted by Samuel Seymour who was there with Long at the time. Stephen Long may be one of the Army men on the left. Chief Big Horse may be the Otoe leader standing alone in the center of the council.

Seymour's Otoe council painting shows a group of Otoe, Missouria, and Iowa Indian leaders meeting and talking with white soldiers. The Plains Indian leader standing alone in the center of that Otoe Council picture may be Big Horse (Shongo Tonga), a headchief of the Otoe-Missouria.[33]

After the Meetings

After the more formal talks, Major Long's men and the Plains Indian leaders often enjoyed each other's company. They ate and drank together, and they traded gifts. They held wrestling matches, horse races, and weapons contests. They played games and entertained each other with shows of strength, speed, and skill. They also told stories, sang songs, made speeches, and discussed things.

At the time of the Otoe Council, Eagle of Delight may have been in her teens. As a girl or young woman, she was probably not at those meetings. But she may have seen or met some of those white men during their visits to Yutan Village. Some of those men may even have seen her during a very special Otoe ceremony held later in 1820.

Chapter 14
The Sun Between Her Eyes

Life would never be the same for Eagle of Delight and her people after Major Long and his men came west in 1819. While Atkinson's men worked on the new fort, Long's men sometimes visited the nearby Otoe-Missouria and Pawnee Indians.

Becoming an Adult

At that time, Eagle of Delight may have been in her teens. Though young, she was almost grown up. Soon she would marry—if she was not already married by then. That was the way of her people in those days.

She was a respected young woman. When she married, she would bring great honor to her husband.

Clues About Her Family

Certain clues about the way Eagle of Delight looked, dressed, and lived show that she came from a

highly respected family.

Her parents' names may now be forgotten. But it appears her father was an important man among his Otoe people. He was a respected adult and probably a leader of some kind, maybe even a chief. He belonged to special groups within his tribe, and he was probably wealthy.

Mark of Honor

We can make good guesses about Eagle of Delight because of a decoration she wore between her eyes when she became an adult—a tiny tattoo.

That tattoo was pale blue and very small. It was hardly even noticeable, but it showed that she was an important and respected person in her family and in her tribe. She was also respected within related tribes, such as the Missouria, the Iowa, the Omaha, the Ponca, and the Winnebago.[34]

In her Otoe culture, that tattoo showed that the girl and her father were members of a special society.

A Special Group

That organization was sometimes called the Night Dance Society or the Chiefs' Dance Society.[35] It was a special part of the culture and religion of the

Otoe and related tribes. It was a society for the chiefs and leaders and for their wives and daughters.

If a man in that society wanted and could afford it, his oldest daughters could have a tattoo or mark of honor put on their foreheads and other places. If the father was very wealthy, he could also have his younger daughters or nieces marked that way.

Women with such a mark on their forehead had a special place in the tribe. They were even allowed to attend some ceremonies and meetings with chiefs.[36]

The Mark

Eagle of Delight would go through a ceremony to have that pale blue circle tattooed on her forehead. She may have had other tattoos, too. (In the later 1800s, tattooing was less common, and tattoos were sometimes hidden by headbands.)

When the people of Eagle of Delight's tribe saw that tattoo on the forehead of a woman, they knew she was from a highly regarded family. It marked her as a good, kind, and respectable person. Her people and related tribes would expect good behavior from that woman all her life. In return, they would honor her as if she were some sort of royalty.[37]

The Ceremony

When the time was right, Eagle of Delight's family prepared for her tattoo ceremony. A holy man was asked to say the right words and do the tattooing. That ceremony usually took place over four days.

Among many Native American cultures, four was an important number and a part of their religion. Many things in their culture came in fours—four seasons, four directions, and more. As a result, many ceremonies lasted for four days and nights.

Before dawn, on all four days of her tattoo ceremony, Eagle of Delight and her family went to a special lodge. Her family brought many gifts to pay for the ceremony, the teachings, and the prayers. Such goods may have included food, horses, furs, robes, blankets, tools, and fine household things.

For the first three mornings, her face was painted with dyes made from plants, minerals from the soil, and charcoal from the fire. While the artist worked, he talked to her about taking her place as a respected adult. He reminded her of her duty to do good things for her people. He also reminded her that her tattoo was both an honor and a responsibility.

The Sun

On the fourth day, just before dawn, the artist drew, then began to tattoo a small, pale blue circle on her forehead. The circle was about the size and shape of a tiny fingernail. It was right between her eyes. That symbol stood for the society, for growing up, for the passing of time, and for the sun and moon.[38]

The sun, moon, and stars were very important to the Plains Indians. Those symbols were especially important in the Night Dance society, too. But the girl's final tattoos and their place on her skin would have been chosen by her father.[39]

During the ceremony, the holy man reminded the girl that her tattoo was an agreement. It was a sign that she agreed to honor and respect herself, her family, her future husband, and her people, all her life. That symbol meant she would always behave properly. She would be a good daughter, a good and faithful wife, and an honorable woman of her tribe.

All during the ceremony, a half-circle of elders watched the girl to see that she acted properly at all times. At the end, the holy man and the others prayed, sang, and smoked a peace pipe.

Uninvited Visitors

Some of Major Long's men visited the village during one such tattooing ceremony. A man named Edwin James wrote about it in his journal. He said that Long's men entered an Otoe earthlodge. There, they saw a girl's face being tattooed in front of her family and a half-circle of Otoe men.[40]

At first, Long's men did not know that they were interrupting a special event. Then their eyes adjusted to the light in the dark lodge. At that point, they realized they were not supposed to be there. But they did not know what to do.

The Otoe people did not know what to do either. They pretended not to see the white people. They pretended Long's men were not in the lodge.

No one said a word. Quietly and respectfully, the white men left the lodge and then the village.

Edwin James took many notes for Major Long. He wrote about what he saw in that lodge. James did not say who the girl was. He may not have known.

That girl may have been Eagle of Delight, or she may have been another girl. There is no way to know.

Chapter 15
The Man Painted Black

During the 1819-1820 meetings and visits with Major O'Fallon and with Major Long's men, one Otoe leader stood out. He was a sub-chief or half-chief, not a main chief or full chief. But he was still an important and respected man.

He was one of three men chosen by his people to act as a tribal policeman at the council meetings. For that reason, he painted his body black and carried a whip. That showed he was a man of power and an Otoe policeman on duty.[41] He took an active part in the conversation while he kept the peace.

Striking the Post

During one of those council meetings, that Otoe policeman listened to the other men as they talked. Then he stepped forward and used his whip to hit a tall post that was stuck in the ground for that purpose.

Hitting or "striking the post" with a stick or whip showed that a man wanted to speak to everyone there. The men at the meeting stopped to listen.[42]

The policeman looked at the faces of the other men sitting in the circle. Then he told them of his many brave deeds in war. He was not bragging. That was the way Otoe men introduced themselves and listed their honors.

The other Otoe-Missouria men listened to him and nodded. They agreed that he spoke the truth. They wanted the white men to know that, too.

Whenever a man struck the post to tell his deeds, his words had to be true. If he lied, the men of his tribe could beat him and call him a liar. They could chase him from the village. A man alone in the wilderness was in great danger.

The Otoe leaders agreed that this policeman's words were true. His many deeds were brave.

A Man of Many Names

That policeman's name was Prairie Wolf, but he was known by many names. Some called him Shaumonekusse (Sha-MON-uh-koo-see). Others called him Chonemonecase (CHON-uh-mon-uh-case-

see). Major Long's men and others also called him Ietan (I-uh-tan), Iotan, L'Itan (Lee-uh-tan), or Yutan (Yoo-tan). Those last four names meant "The Comanche" in other languages.

But Prairie Wolf was not a member of the Comanche tribe, he was an Otoe. He may even have been the son of an Otoe chief.

So how did he get that "Comanche" name?

Plains Indian men of many tribes often changed their names to celebrate a special honor, a brave deed, or a victory over another tribe. That was a common custom.

Prairie Wolf may have earned his name, The Comanche, when he led a war party against that much-larger and more powerful tribe to the south—and beat them. That battle may even have happened in 1820 while Stephen Long's men were nearby.[43]

Taking Note of Prairie Wolf

Major Long's men watched and listened at the councils and during visits to the villages. Some of them made notes and wrote things in their journals.

They wrote many good things about Prairie Wolf. They wrote that he was brave, strong, and

intelligent. They wrote that he had dark piercing eyes. They said he was tall, muscular, and stern, but also good-natured, with a very good sense of humor. Thomas Say of the Long Expedition even called Prairie Wolf "one of the most brave and generous warriors of the Missouri Valley."[44]

The policeman's own people and the white men who knew him treated Prairie Wolf as a great warrior and a good sub-chief. Everyone seemed to like and respect him. For the most part, he seemed to fit the model of the ideal Otoe man who was brave, gentle, truthful, and generous.[45]

He was only a minor chief in those days. Some years later, he would become a main chief of his Otoe tribe. But before that happened, Prairie Wolf would marry Eagle of Delight. (See page 102 for a picture of Prairie Wolf.)

Chapter 16
Bride Price

Somewhere around the time of Stephen Long's visits, Eagle of Delight became the wife of Prairie Wolf. He was that black-painted policeman who had impressed Long's men.

The Proposal

Before that marriage, Prairie Wolf may have told his family he wanted to marry Eagle of Delight. He may have sent his father or brother to her lodge to see how her family felt about such a marriage.

Her father would then have asked the women of his own clan if such a marriage was proper and good for the families, the clans, and the tribe.

If both families thought the two people were a good match, then Prairie Wolf may have offered food, horses, and other things to the girl's father. In that way, he asked permission to marry her. Prairie

Wolf might have left those things at the doorway of the lodge where Eagle of Delight's father lived.

The Price

Horses, goods, and other things that were offered in trade to buy a wife were called a bride price.[46] If an Otoe man offered many good things for his wife-to-be, it showed he was a good provider. It also showed that the girl was honored and respected by her new husband and by other people.

Paying a bride price was a common custom among the Otoe and other Plains Indians in the 1800s. Many white societies of that time had a kind of bride price, too. It was called a dowry (dow-ree), but it worked very differently.

A Girl's Place

In the 1800s, things were very different than they are today. Then, most girls from all societies had very little choice in who they would marry, where they would live, what they could own, or what they could do with their own lives.

People did not live as long then, too, and only a few white children went to school beyond the 8th grade. Girls often married early.

In many societies, marriage often had little to do with love. Most marriages were arranged by parents. The parents often wanted the husband to be older, richer, a good provider, and from a good family, so he could take good care of his wife and their children.

A girl was generally expected to marry the man her family chose for her—whether she liked him or not. Survival and family connections were often considered more important than love.

However, most parents considered the girl's feelings, as well. That was often true in both white families and Native American families.[47]

Finding the Right Bride Price

In those days, the father of an Otoe bride often decided if a given bride price was high enough to allow his daughter to marry with honor. If he felt the price was too low, he left the goods at his doorway until more things were added—or until all the offerings were taken back by the rejected man.

When the father felt the price was high enough to honor his daughter and himself, he took the gifts for his own or gave them away. Then after a wedding feast, the couple began their life together.[48]

A Good Match

Prairie Wolf was much older than Eagle of Delight. Despite his age, he was a good match for her. He was an honored sub-chief, and they were both from respected families. They would bring each other many honors. Together, they would be more important and honored than they were by themselves.

More Than One Wife

Everyone knew that Prairie Wolf already had four wives. Otoe society encouraged a man to have just one wife. But having more than one wife was allowed among the Otoe and some other Plains Indian tribes during the 1800s.

However, having more than one wife came at a high cost. To do that, a man had to prove he could provide food and protection for all his wives and all his children, and for all his wives' parents as well.[49]

For that reason, some Plains Indian men married sisters. That was acceptable among many Native American tribes then. If the sisters got along well, such marriages could make family ties stronger—without adding more in-laws for the husband to feed.

Life on the plains was dangerous. Men were

often hurt or killed in war or while hunting. So there were usually more women and children than men in a tribe. Widows, orphans, old people, and unmarried women also needed men to supply meat for them, so they could all survive. Having two or more wives was one way of helping and providing for each other.

A Respectable Husband

The Otoe people did not respect a lazy man or a man who did not provide for his family. Prairie Wolf was well respected, so he must have been a good hunter and husband—and a very busy one. After he married Eagle of Delight, he had five wives and families to protect and feed.

No one knows how Eagle of Delight felt about her marriage. And no one seems to know when Prairie Wolf and Eagle of Delight married or how old they were then. But it is likely that their marriage took place somewhere around the time that the Stephen Long Expedition visited the Council Bluff area and the Otoe.

Chapter 17

A Change of Plans

During that winter of 1819-1820, Major Long returned to the East to meet with President James Monroe and other men.

They talked about the goals of the Atkinson and Long expedition and about how much money that mission had already cost. Congress had recently refused to grant more money for the expedition, so some plans needed to be changed.[50]

What To Consider

Major Long told the president that the new steamboats had not worked well on the Missouri River. Flat-bottom boats worked better. So those would generally be used to move men, their families, food supplies, farm animals, and other goods and materials up and down the river. Those boats would also be used to ship furs from Fort Atkinson to cities

in the East and elsewhere.

Colonel Atkinson's men were making progress building that new fort. It was already becoming a valuable fur trade and military center leading to the Rocky Mountains.

Big Business—The Fur Trade

In those days, the fur trade was important business. Until the 1850s, people all over the world used furs and leather hides for most of their clothing, hats, boots, and more, so furs were in great demand.

Most of those furs came from the northern plains and the Rocky Mountains. There, beaver and other animals were trapped. Their furs and hides were then bought, sold, or traded by fur trappers, mountain men, Native Americans, and fur traders.

River Trade

The furs were then taken downriver by horse or canoe to Fort Atkinson, Fort Lisa, and other trading posts. From there, the furs went upriver to the Great Lakes and Canada or downriver to St. Louis and New Orleans. Most of those furs went to big cities in eastern America, Canada, or Europe.

That fur trade business helped make Fort

Atkinson an important trading post. It also helped make America an important world trade partner.

Keeping the peace across the Central Plains and the Rocky Mountains was especially important for that business and for America.

New Orders

The president and Major Long talked about the fur trade and about Long's meetings with the Plains Indians. They talked about other native people who lived further west, too.

Soon, the president gave Major Long new orders. Long and about twenty men were to go on an overland journey in the spring. They would travel west along the Platte River to the Rocky Mountains.

They were to try to find the source (or start) of several major rivers, including the Platte. They were also to report on the land, the native people, and anything else they saw while out there.

Return to the Fort

In the spring of 1820, Major Long returned to Fort Atkinson. While he prepared for his journey west, some of his men visited the Otoe and Pawnee villages again, making more notes in their journals.

EAGLE OF DELIGHT 72

When the time was right, Long led his small band of men west along the Platte River to the Rocky Mountains. Along the way, they saw a very tall mountain. Long's men named it Long's Peak, in honor of their leader.

Major Stephen H. Long on the Rocky Mountain Expedition, painting by Titian Ramsey Peale. (Titian Ramsey Peale was an artist with the Stephen Long expedition.) (*Courtesy, George Turak, Turak Gallery, Nottingham, PA*)

Chapter 18
Special Invitation

While Major Long and his men were moving west, Major Benjamin O'Fallon, the Indian agent, made plans to take a trip east.

To Stop the Trouble

Early in 1821, O'Fallon heard that some of his native tribes were fighting with each other and also with white men. The Indian agent worried that war might come to the plains. Most of all, he worried that his Plains Indians might become involved.

O'Fallon wanted to put an end to such problems. After being on the plains for two years, the twenty-six-year-old bachelor was also ready to take a vacation back East—and he had a plan to do both.[51]

He decided to take about fifteen chiefs with him to Washington D.C. to meet and talk with the president. So he sent messengers to the Otoe-

Missouria, Omaha, Kansa, and the Pawnee bands. He told them to choose men to represent them.

Choosing Representatives

The Otoe leaders chose at least two sub-chiefs to represent them back east. One of those men was Prairie Wolf, Eagle of Delight's husband.

The other man who was chosen also had at least two names. One of those was Good Horse or Shongo Pi. Another of his names was Choncape (pronounced Chon-cop-ee or Shawn-cop-ee). He was related to Chief Big Horse.[52]

The name Choncape meant "The Kansa" or "Big Kansa," but that sub-chief was Otoe, not Kansa. He had probably re-named himself for a victory over the Kansa tribe.

Many Questions

Eagle of Delight may have been newly married when her husband Prairie Wolf and Choncape were chosen to represent their people on the journey east.

Soon Prairie Wolf would be leaving with Choncape. The two men would be traveling far. They would be gone a long time. If they ran into trouble, they might never return.

Eagle of Delight probably did not expect to go on that long journey with the two men. She probably expected to stay home with Prairie Wolf's other wives and the rest of the Otoe people.

Choncape or Big Kansa, a sub-chief of the Otoe, from an 1830s McKenney-Hall lithograph. (*Courtesy, from a Private Collection*) Choncape and Eagle of Delight's husband Prairie Wolf were the two sub-chiefs chosen to represent their Otoe people in the East in 1821-1822.

Wondering

Eagle of Delight must have wondered who would care for Prairie Wolf's big family while he was gone. Who would hunt meat and care for all of them over the long winter?

Prairie Wolf was a good leader and provider, so maybe his father and brother would care for his family while he was gone.

But what would happen if Prairie Wolf did not come back? He could have an accident along the way. Or he could get sick and die from one of the many illnesses that had come with the white people.

Voleur and other Plains Indian people had died of those terrible diseases—smallpox, measles, cholera, and more. What would happen if Eagle of Delight's husband became ill and did not come back?

Making Preparations

Eagle of Delight had many reasons to worry, but she also had many things to do to keep her busy. She had to help her husband get ready to make the long journey. She had to help prepare hides to make new robes and moccasins for him. She had to make fine gifts for her husband to give to the president, too.

At the same time, she had to help with the daily chores. She had to tend her fields and prepare food for her family. There were many things to do.

Preparations for the White Men, Too

The Indian agent named O'Fallon also needed to do some things before he could take Prairie Wolf and the other chiefs back East with him.

Before making such a journey, he had to get permission from men in the government. One of those men was Major O'Fallon's uncle, William Clark. Clark was also one of O'Fallon's bosses.

Clark worked for the American government and was in charge of the Native Americans and their agents in the upper Missouri River area. He and his family also had a big fur trade business of their own. So he had control of most of the trappers and traders of that upper Missouri River area.

Today such close business and family ties could be considered a conflict of interest. Back then, business arrangements like that were common.

William Clark agreed with his nephew. Clark wanted the Plains Indian chiefs to visit the Eastern cities to see the large number of people who lived

there. But Clark also wanted O'Fallon and those Plains Indian leaders to visit him at his headquarters in the fur trade city of St. Louis in Missouri Territory.

The Territories

Back in 1812, an area of land at the lowest or southern end of the Louisiana Territory had become the state of Louisiana.

To avoid confusion, most of the rest of that huge Louisiana Territory was renamed Missouri Territory. St. Louis became its capital.

The Otoe, Omaha, Pawnee, Kansa, and many other Native Americans lived in the far northern area of that Missouri Territory. By 1819, that northern area was often called "Indian Country" on maps.

Later that northern or "Indian Country" land would again be cut up into two smaller parts. Those parts would then be called Nebraska Territory and Kansas Territory. (Years later, those two would also be cut up smaller and would become many states.)

Nebraska Territory would not be open for white settlement until the 1850s and 1860s. However, that did not keep missionaries, traders, and some other white men from living there sooner, along the rivers.

Chapter 19

Speaking for Mother Earth

In the early 1800s, Native Americans did not know all the names the white men called the parts of that old Louisiana Territory. They only knew what they called their own land. They often called it "Mother" or "Mother Earth" in their own language.

The Otoe and other tribes loved and respected the earth. They did not feel they owned it. They just felt it was theirs to use. And they did not want other people moving onto that ground and destroying it.

Their teachings taught them to use nature wisely. They were to take only what they needed from it. Then they were to give good things back to it. That was all part of their religion and their culture.

Different Values

The Plains Indians did not understand why white people treated the land so differently—cutting

down the few trees on the plains and pulling up the stumps. The Plains Indians did not understand why white people built fences to keep some animals in and others out. They did not know why white people tore up the earth and then turned the grassy sod upside down when they planted their fields.

They did not understand why white men did the farming. Among most Plains Indian tribes, the women planted and harvested the crops. And they often planted those crops in tiny hills, instead of in rows, as white people did. Native American men did not usually farm. Instead, they did the hunting and protected their families and tribe. That was their culture and lifestyle.

Most Native Americans also did not understand the white man's language, religion, or writings. The Plains Indians were happy with their own religion, their way of doing things, and their way of life.

They did not want to do things the way white people did. They did not want new people moving onto their lands. They did not want missionaries and agents telling them how to live. They did not like the many ways their world was changing.

New Sicknesses

The Plains Indians especially did not want the sicknesses that often came with the new people. The Native Americans had no natural protection from those diseases. They could not see the germs that made them sick. They did not know what caused those illnesses—smallpox, diphtheria, cholera, chicken pox, measles, and more—and they did not know how to protect themselves from them.

New People

The Plains Indians felt the white people had many strange things and odd customs that made very little sense to them. Still, most of the farming tribes were friendly toward the white people.

Most white people were just passing through, across those lands. Native Americans were happy to see the visitors come to trade. They were happier when the visitors moved on. Lately, though, more new people were moving in—and staying—and telling the Plains Indians how they should live.

Reasons to Visit the East

The Indian agents worried that the Plains Indians would turn angry and hostile toward the new

white people. The agents did not want any problems.

The agents wanted the Plains Indians to visit the East to see how many white people lived there. Like the earlier explorers, the agents wanted the Native Americans to see the weapons and manpower that could be used against them if they made war.

The chiefs had their own reasons for accepting the offer to go east. They wanted to tell the leader of the white people to stop sending his people west. They wanted him to stop trying to change the Plains Indians and their way of life.

That was what the tribes wanted to tell the man called President Monroe. For that reason, the Otoe-Missouria representatives and other Plains Indian leaders were eager to send some of their leaders on a journey east with Major O'Fallon.

Chapter 20

Leaving Home

Eagle of Delight did not have long to worry about her husband being gone from her. Prairie Wolf did not want to be away from her either.

Perhaps he worried about what would happen to his new wife while he was gone. Or maybe he wanted to show her off to the other chiefs and to the white people back East.

After all, she was young, pretty, and well respected. She also did her best to make her husband look good. Besides that, Prairie Wolf really seemed to care for her.

It helped that she wore the pale blue tattoo—the mark of honor—between her eyes. That meant she was special. She could go places, meet with chiefs, and do things that other women could not do.

Prairie Wolf decided to take Eagle of Delight

with him on the journey. She would travel with him and with fifteen other Plains Indian men. She would go with them to meet the Great White Father known as President James Monroe.

No one knows how Eagle of Delight felt about that decision. Had she asked to go? Did she even want to go? It did not matter. The choice was made.

Great Expectations

Several accounts say Eagle of Delight was the only woman in that delegation.[53] She was young, hardly more than a girl, but according to her people's customs, she was a woman, a wife, and a respected lady. Great things would be expected of her, as well.

She would be an ambassador for her Otoe-Missouria people. As the wife of a sub-chief and the daughter of another important man, she was expected to honor her husband and represent her people well.

Eagle of Delight would also represent all Native American women of the plains. She would be one of the first and youngest Plains Indian women the white people back East would ever see.

If a woman were to go with the delegates, it should be such a woman with the mark of honor.

Getting Ready

Eagle of Delight probably felt honored to go with her husband. She would do her best to represent their people. She would try to live up to her tribe's expectations—although she was probably a bit afraid of going so far away from home, for so long.

She did not know it then, but they would be gone most of a year. They would spend the rest of the spring and part of the summer traveling to St. Louis, then on to Washington D.C.—a journey of about 1,400 miles. They would spend the fall and winter in the Eastern cities, before heading home again—another 1,400 miles in the spring.

But she had no time to worry about that. She had a lot to do to get herself and her husband ready for the long trip.

Chapter 21
The Journey Begins

On the day her journey began, Eagle of Delight dressed in some of her finest clothes and best moccasins. She combed her long black hair, then formed it into two braids. She put her finest earrings into the many small holes in her ears.

Then she probably painted the part in her hair red with something from the earth called vermilion (ver-million). Many Plains Indians used that red paint as both a decoration and a prayer for courage.[54]

Eagle of Delight knew she had to look her best, but she must always let her husband look even better. He was a great warrior and sub-chief. He and Choncape were the ones who had been chosen to represent their Otoe people, not her.

Still, her tribe's teachings said she must always act respectably and respectfully. She had to do that

no matter how strange the white people might seem to her. It did not matter how odd she might find their customs, their clothes, or their towns.

Her own people—and all Plains Indian women—would be judged by the way she behaved. She must never forget that.

On the Road

When she finished her preparations, Eagle of Delight joined her husband. She may have walked or ridden her horse a few steps behind his, as was proper. They took their packhorses and joined Choncape, and perhaps some other men of their tribe.

Along the way, they met with Major O'Fallon, his black servant, other Indian agents and translators, and the leaders of the other tribes. Near the Missouri River, they all turned south to go meet O'Fallon's uncle, William Clark, in St. Louis.

The Delegates

Together, those sixteen Plains Indian men—and the one Plains Indian woman—were the representatives of their people. They were the official 1821-1822 Plains Indian Delegates from the Upper (or Northern) Missouri River region.

Reports of that time noted that those seventeen Plains Indians were members of the Kansa, the Otoe and Missouria, the Omaha, and at least three of the four bands of the Pawnee. Most or all of those Native American men were chiefs or sub-chiefs, of various ages. Eagle of Delight, the only female among them, was somewhere between 14 and 18 years old.[55]

Tribal Relationships

The people of that delegation were from different groups. They did not always get along well.

The Otoe, Missouria, and Omaha people were somewhat related. They lived near each other and spoke a similar language. Sometimes they got along well together, as they usually did on that trip.

The Kansa were distant relatives of the Omaha, Otoe, and Missouria, and spoke a similar language. However, the Kansa tribe was much larger in number and much more warlike than those other three. The Kansa also lived much further south. They did not get along well with any of the others in the delegation.

The four bands of the Pawnee tribe lived further west. They were not related to the other tribes. The Pawnee spoke a very different language than all those

other people. The Skidi (Skee-dee, Wolf, or Loup) Pawnee and the three other Southband Pawnee groups even had some differences within their own language and customs.

Each of those four Pawnee bands was very fierce in those days. Together, they made up a very large, powerful, and often warlike nation. But even those four Pawnee groups did not always get along well with each other. Nor did their leaders.

Who's in Charge?

The Pawnee chiefs and sub-chiefs of that 1821 delegation often argued, even among themselves. They were very proud and powerful men. And they were used to being in charge of many other people.

Over the years, the Pawnee had also been sometime-friends and sometime-enemies of the other tribes on the Great Plains. The Otoe, Missouria, and Omaha people had even lived with some of the Pawnee bands during bad times, but had fought against them at other times.

The proud Pawnee and Kansa chiefs all thought they should be the ones to lead the smaller tribes. That did not help the delegates get along well.[56]

One Headchief Only

The Kansa, Otoe-Missouria, Omaha, and Pawnee chiefs had never before worked together as one group. All of them were important men.

With so many chiefs from so many different tribes, those men often argued over who should lead and who should follow, especially at first. The Grand Pawnee chief named Sharitarish (Share-uh-tare-ish) soon decided that he was in charge of all the other Plains Indian men and began to give the orders.

Before long, Major Benjamin O'Fallon, the Indian agent, had to remind all the delegates that he was the leader and the headchief of the group. He told them that he expected all the delegates to follow his orders on the journey and in Washington D.C. And from then on, those 1821 delegates generally did so, and worked together.

Chapter 22
East Meets West

On their journey, Eagle of Delight and the other delegates saw many new and surprising things. All of that made them excited—and sometimes uneasy.

That kept the interpreters busy, too. They tried to explain things and keep the peace between the tribes. To do that, they had to speak English and two different Indian languages, and sometimes French.

They also had to answer many questions about the new things the delegates saw along the way. And there were so many questions and new experiences for all of them.

Seeing and Doing New Things

On the way to St. Louis, many of the delegates saw and did things they had never done before. They were used to living in earthlodges or hide-covered tipis. They were used to camping out. But sometimes

Major O'Fallon had them stay in wood or stone houses called inns or hotels, just like white men did. That may have been the first time some of those delegates were ever in a white man's house.

The Plains Indian farming tribes were used to living with large families—sometimes 20 to 40 people in a lodge. But they were not used to having a room of their own with a door that could be closed.

They were used to sleeping on grass mats or furs on the ground. They were not used to sleeping on beds suspended by ropes or by wooden frames above the ground, as most beds were then.

The Plains Indians were used to sitting on the ground, on blankets or furs. They were not used to sitting in chairs while talking to each other. They were not used to sitting at tables to eat. Nor did they know how to use plates, glasses, forks, and napkins at a table. They had many new things to learn while visiting the white man's world!

Red Head's Town

Many weeks and about 500 miles later, the delegates reached St. Louis. That was where William Clark lived. Clark had red hair. He was often called

Red Head or Red Hair, so the Plains Indians called his city of St. Louis "Red Head's Town."

William Clark, portrait by Charles Willson Peale, from life, 1807-1808. (*Courtesy, Independence National Historical Park*). William Clark was sometimes called Red Head or Red Hair.

Some 1821 delegates had already visited William Clark at St. Louis. Petalesharo (Pete-uh-luh-shar-oh), the Skidi Pawnee sub-chief, had visited Clark around 1815. Some Otoe leaders may also have visited Clark there in 1814, 1817, or other years.[57]

At Red Head's Town

At St. Louis, the delegates talked with William Clark. They ate a lot while they were there, too. Food bills show that the seventeen delegates ate more than 450 pounds of beef during those twelve days.

Meanwhile, O'Fallon had new shoes put on the horses and mules. He hired a cook and other men, and he bought more wagons and supplies to take along on the next part of their trip. Then the delegates turned east toward Washington D.C., which was also known as Washington City or just Washington in those days. (There was no Washington state yet.)

Washington Arrival

On the next leg of their journey, the delegates traveled 900 more miles in six weeks. They reached Washington D.C. in late November of 1821. Eastern newspapers carried stories about their arrival. The stories said the delegates were "from the most remote tribes with which we have [contact]" and said the Pawnee were "warlike" and "formidable."[58]

More Inns for the Travelers

In Washington, Major O'Fallon took the delegates to a hotel. This one was George Miller's

Tavern. That three-story building had a food-and-drink room on the ground floor and hotel rooms on the two upper floors. It often housed travelers and even some slaves who were to be sold at market.

The Plains Indian delegates lived at that inn while they were in town. The government paid 75 cents a day per person for their rooms and food.[59]

The delegates may have been housed there because O'Fallon had rushed to put that trip together. His idea was somewhat new, and the government was not really prepared to pay for all those visitors yet.

Separate Quarters

O'Fallon, however, chose to stay at another, more expensive place—first at Jesse Brown's new Indian Queen Hotel, a block away from George Miller's Tavern. Then he moved to Tennison's Inn.

Both of those hotels charged $1.25 per person per day. (In following years, the government allowed more money for the visits. After that, O'Fallon housed his delegates at those more expensive hotels.)

Fitting and Proper

In their first four days in town, the 1821 delegates received visits from many tailors,

shoemakers, and other tradesmen. Those business people came to measure the Plains Indians so they could make clothes and other fine gifts for them. The native visitors would receive those things from the president during their stay in Washington City.

Chapter 23

Tours and Admirers

Major O'Fallon and his first group of Plains Indian delegates expected to meet the president in the White House very soon after coming to Washington But the president was busy with other government meetings at that time.

If they met with him at all, it was only for a few minutes. So, after waiting a week to meet formally with the president, O'Fallon sent his delegates on a tour of some of the other big cities in the East—including Baltimore, Philadelphia, and New York.[60]

On those tours, the delegates visited theaters, circuses, churches, museums, farms, and more. They saw battleships, navy yards, army forts, and military parades. They met with important people and saw many strange and interesting things. They saw things of peace and things of war.

Different Viewpoints

As usual, the government really wanted the Plains Indians to be impressed by the military power that could be used against them if they ever decided to make war on the white people. But Easterners were much more excited about just seeing and meeting the Native Americans from the plains than in trying to scare them.

Crowds of Easterners followed the delegates down the streets. They wanted to see and touch the visitors and their strange native clothes. Those Plains Indians were so similar and yet so different from the Native Americans of the East.

Special Report

The delegates returned to Washington D.C. in late December. About that same time, Congress received a report about a young Pawnee hero. That young man had rescued a young Comanche girl from death on the plains, a few years before.

That hero was Petalesharo. He was the young Skidi Pawnee sub-chief who happened to be visiting the East right then, as one of the 1821 delegates.

Petalesharo (also known as *Petalesharro*, Man Chief, or Generous Chief) of the Skidi Pawnee, portrait by Charles Bird King, 1822. (*Courtesy, The White House Collection*) He was a hero on the plains and one of the 1821-1822 delegates.

Petalesharo often wore a full warbonnet of eagle feathers. That headdress was reportedly the first one of its kind ever seen in the East. Each feather was a symbol of one of that man's many brave deeds.

Soon, everyone in the East was talking about the romantic young Pawnee hero. They all wanted to meet him. They wanted to meet the other delegates, too, especially the young Otoe woman—even though she was not the Comanche girl the Pawnee hero had rescued.

Special Visit to the White House

After reading a newspaper story about the young Pawnee hero and the other delegates, the president sent for O'Fallon's visitors. They met at a reception at the White House on New Year's Day. Then the president invited them to the annual dance at the White House that afternoon.

President Monroe and his wife hosted the dance. Important guests included Secretary of War John C. Calhoun, Secretary of State John Quincy Adams (who would be the next president of the United States), Supreme Court Chief Justice John Marshall, and others. Many American Congressmen attended.

The room was also full of other Easterners and diplomats from Great Britain, France, Sweden, Russia, and other countries. The U.S. Marine Corps Band provided the music for the dance.

A Matter of Style

Many society people came to that dance in their best and fanciest clothes. But the 1821 delegates were the hit of the party. Those native men showed up late, wearing their traditional Plains Indian clothing—breechcloths, blankets, buffalo robes, bear claws, and feathered warbonnets.[61]

Three of those Plains Indian men wore face paint or war paint as a decoration. One of them—Petalesharo or Man Chief, of the Skidi Pawnee—also wore his popular warbonnet of eagle feathers. But he was not the only one to do that.

Eagle of Delight's husband Prairie Wolf also wore his own unusual-looking headdress. It looked like a gold crown, topped by a nest of red horsehair, and a set of up-raised buffalo horns with tassels at the points.

That headdress must have looked very odd to the white people, but the Otoe half-chief wore it proudly, with style and grace. It was a symbol of his place and position in his tribe. With that headdress, he wore necklaces of leather, beads, bear claws, and one peace medal.

Shaumonekusse (Prairie Wolf, Iotan, Iatan, or Yutan) of the Otoe (Husband of Eagle of Delight), portrait by Charles Bird King, 1822. (*Courtesy, The White House Collection*)

A Mix of Styles

Easterners also admired Prairie Wolf's wife, Eagle of Delight. She wore her long black hair in her usual style, parted in the middle and braided on both sides of her head. The part in her hair was painted

red, and her black hair may have been decorated with silver disks, as it often was.

She wore some of her own native clothes to the party, including her beaded moccasins and deerskin dress. She also wore some of the clothes she had received as gifts from the government. Those included a green coat and a pair of red pantaloons. Pantaloons were long, lacy pants worn under a woman's dress.

Eagle of Delight must have wondered about her new and brightly-colored pantaloons. Women in her tribe did not wear long pants, and she did not yet have any fancy dresses to wear with those pants.

She had only her beaded buckskin dress, which was very beautiful in its own way. She wore the pantaloons and coat with that deerskin dress and moccasins.

Eagle of Delight's mix of native and society clothes must have looked very unusual, but she did not seem to mind. She had her own kind of style, too, and that helped make her the center of attention.

At the Center

Eagle of Delight was truly admired. Some

society women were even jealous of her beauty and the attention she received.

Laura Wirt, the daughter of an important government official, later met Eagle of Delight at the home of the French ambassador. Miss Wirt then wrote to a friend, saying that "since the Plains Indians had come east, no one talked of anything [else]." [62]

She described Eagle of Delight as, "quite a pretty woman. At least she is, no doubt, considered so in her own nation, and even with us, her modest, good-natured [face] would pass here for [pretty]. She is not more than fifteen they say, tho' I should think her two or three years older. She is the favorite wife of one of the Chiefs."

Eagle of Delight did not really know what to think about so many people watching her all the time, but she handled the situation well. She did not seem to worry that some of those Eastern women were jealous of her. Many Easterners truly admired her.

Chapter 24
The Darling of Washington Society

Before and after that New Year's meeting at the White House, the plains chiefs and Eagle of Delight visited many important people of the East in their homes. Eagle of Delight liked to visit with the Easterners through an interpreter. She especially loved to hold, feed, and play with the little children of her new friends.[63]

Just by being herself, she helped Easterners see that the Plains Indians were people with families— just the same as white people were. Because of her, Easterners realized that they all had a lot in common with the Plains Indians, despite very different backgrounds and cultures.

All during that 1821-1822 Washington visit, Eagle of Delight represented her people well. She was so polite and so charming that she became a

favorite of the people of the East and was sometimes called "the Darling of Washington (D.C.) Society."[64]

Shaking Hands with a Skeleton

Eagle of Delight and her husband were both well-liked, well-mannered, intelligent people. Prairie Wolf seemed to love his wife very much, but he was sometimes stern and a little jealous around her. He also had a bit of a temper, but he had a wonderful sense of humor, too.

The two of them were often invited to the home of a Washington doctor named Jonathan Barber. There, Eagle of Delight spoke through an interpreter, but Prairie Wolf wanted to learn the English language himself. He listened to the white people's words, then learned to repeat them correctly. He learned words very quickly.

One day when Prairie Wolf, Eagle of Delight, and other delegates were visiting their doctor friend, they saw something very strange. They noticed a real, full-size human skeleton that the doctor had hanging in his office closet for medical purposes.

Eagle of Delight's husband loved jokes and enjoyed speaking English. So, either he or one of the

other men walked right up and shook the handbones of the doctor's skeleton. At the same time, the native delegate bowed and said, "How do you do?" in almost perfect English.[65]

That was a polite way of saying hello, but no one expected a Plains Indian to say hello so formally, and in English, to a skeleton. Everyone in the room laughed at the joke. Newspapers then carried the story so other Easterners could enjoy it.

Celebrating the Visitors

Easterners thought the Plains Indians were exciting and romantic. Newspapers carried stories about them. Many people wrote essays, poems, and plays about them. Easterners were fascinated with the Native Americans and gave them many gifts and even some awards during that fall and winter.

A Proper Wife

Those Easterners did not always understand that the Plains Indian delegates were from different tribes. They did not understand that the Kansa, Omaha, Otoe-Missouria, and Pawnee were alike in some ways but very different in others, such as in language and customs.

Some Easterners thought Man Chief or Petalesharo (the young Skidi Pawnee sub-chief) and Eagle of Delight (the young Otoe woman) made a very handsome couple. Those people seemed to think that her husband was too old for her. They may have thought she should have married a younger man. But that was none of their business.

Eagle of Delight was married to Prairie Wolf. She was always a very proper wife for him. She respected her husband and would do nothing to anger him or to make him look bad in the eyes of the white people or his fellow delegates.

When she received fine gifts of jewelry from her new friends, Eagle of Delight often gave the best of those things to her husband to wear. She did that so he would be noticed, instead of her.

May I Have This Dance?

Several of the Plains Indian delegates became very popular and had lots of friends. They received many other invitations and attended formal parties, dances, and other gatherings at the homes, clubs, and theaters of their new friends in the East.

One day in January 1822, they attended a dance

at the home of the French ambassador. They were there with many fashionable society people.

At that party, the French ambassador asked Eagle of Delight to dance the first dance with him. His request was intended to be a great honor, but she did not understand the custom. She politely turned down his invitation and the other invitations that followed.[66] In her culture, dancing was done very differently.

Dancing Differences

Among Plains Indians, dancing was usually part of a ceremony. It had special meanings and traditional songs. Dancing often had something to do with religion and giving thanks. To Eagle of Delight, dancing was also a part of her special Night Dance Society, so it was something to be done according to special rules and customs.

In most Plains Indian cultures, couples did not dance together. Instead, Native American people usually danced by themselves—but they did that in a big group within a huge circle, with only a drum and singing as music. Each song had its own form of dance steps and traditional clothing. Most of the time,

Native American men and women did not use the same dance steps. And most of the time, they did not dance at the same time.

Among Eagle of Delight's people, dancing with a man—especially a man who was not her husband—might have been considered improper. To dance in that way might have shown disrespect for the man who was her husband.

Eagle of Delight had been carefully taught. She would not disrespect her husband in any way. Instead, she politely turned down the other men's offers. Then she spent her time watching the white people dance. Those dances, the dance music, and the musical instruments must have seemed very strange and perhaps even amusing to her.

Chapter 25
The Last White House Welcome

On February 4, 1822, O'Fallon's Plains Indian delegates met President James Monroe at the White House once again. Several government men and newspaper reporters came to see the chiefs.[67]

New Clothes

The Plains Indian men wore their new clothes to the meeting. Their blue and red army coats were given to them by the president. The coats had big metal buttons and silver tassels on the shoulders.

The coats of the full chiefs had silver tassels on both shoulders. But the sub-chiefs each had a silver tassel on just one shoulder, to show that they were just half-chiefs.

At this meeting, all the chiefs wore white men's shirts, pants, tall black hats, and tall black boots, to go with their army coats. Those clothes had been

made to fit them, but on those Native American men, the clothes looked too tight and uncomfortable.

The chiefs brought presents for the president. They gave him fine robes, weapons, tools, headdresses, and other gifts. They asked him to keep those presents so that people would always know what the artifacts of the Plains Indians looked like. (Artifacts are the tools and weapons people make and use in their culture.)

Speaking for Their People

The men made many speeches that were carefully translated into English and the native languages. Their words were generally friendly.

The chiefs thanked the president for all his fine gifts. Then they told him that what they really wanted was for him to keep white people away from the plains. The chiefs wanted their own people to be left alone to live just as they had always lived in the old days. They were afraid white people would move onto their lands and change those old ways too much.

When the speeches were over, the president gave away flags with stars, stripes, and eagles painted on them. Some of those flags were almost 5 feet high

by 7½ feet wide. The president also gave each full chief a Monroe peace medal.

Monroe Peace Medal (front). (*From the author's collection*)

Wanting to Speak

Silently, Eagle of Delight watched everything, but she took no active part in the meeting. However, she had noticed something, and she wanted to talk about it.

Chapter 26
The Words of a Woman

The president seemed to think that Eagle of Delight was charming in her red pantaloons and green coat. He noticed that, throughout the meeting, she stayed quietly in the background, behind her husband. But she seemed to want to say something.

Other white men and the chiefs noticed that Eagle of Delight wanted to say something, too. They wondered what important thing she wanted to say.

After all, she was not a man or a chief. She was not even one of the chosen representatives. She was just there as the wife of one of them. And she was hardly more than a girl—though she did wear a special mark of honor.

If she spoke, would she embarrass them all with her words? Would she embarrass her husband and herself and her people?

She really wanted to speak, but it might not have been her place to talk in a meeting of so many men. If she spoke up, would she shame her husband and the delegates? She did not want to do anything wrong, but she really wanted to say something important.

Half-jokingly, some of the chiefs encouraged her to make a speech of her own—just as they had done. The president, too, invited her to speak. She was so young. They all probably thought she would say something silly or just ask for a gift for herself.

Speaking Up

Finally, Eagle of Delight decided that her words were important. She stepped forward to speak. But she did not say something silly. Instead, she voiced her concerns in a careful, polite, and roundabout way.

First, she stated that the president had given peace medals to the full-chiefs. Then she said those men looked very handsome in their new clothes and medals.[68]

Next, she noted that the president had not given medals to the sub-chiefs—such as the young Pawnee hero Petalesharo and her own husband Prairie Wolf or the other Otoe sub-chief Choncape.

Her words let the men know that she thought the half-chiefs were also very important. She indicated that they represented their people, too, and someday they might go on to become full-chiefs.

If so, and if they were to receive medals of their own from the president, then those medals would help them remember their promises of peace and friendship—and their own visit to the East, too.

Monroe Peace Medal (back). (*From the author's collection*)

Reactions to Her Words

Some of the men were surprised by what Eagle

of Delight said. But her words seemed to please President Monroe. He saw their value.

He also saw that she was a wise young woman and a good wife for a sub-chief who might be head chief someday. Her words and her actions showed that she was an excellent ambassador for the Plains Indians.

In those days, Monroe peace medals came in three sizes, too. So the president called for his men to bring out some of the smaller ones. He gave one of those smaller medals to each of the sub-chiefs, including Prairie Wolf.

Then there was the question of what gift to give Eagle of Delight. She may have deserved a peace medal, too, but that did not seem to be an appropriate gift for a woman. What else could she want?

Speaking for Herself

Before answering, Eagle of Delight may have looked around at the blue and red army coats and other new clothes and gifts worn by the chiefs.

She may have looked down at her pretty red pantaloons and green cape that she wore. How odd they must have looked with her deerskin dress and

moccasins. Then she knew just what she wanted, to help her remember her visit to the East.

Newspaper stories said Eagle of Delight smiled shyly. Then she asked for something for herself—a dress like the ones the white women wore.[69]

The president smiled and agreed to grant her wish, but dresses were not easy to get in those days.

Stores of that time carried very few ready-made clothes. Most dresses had to be hand-made. They took a long time and a lot of work to make.

Eagle of Delight may have had to wait a few days for her dress.

Time to Relax

After all the speeches, the men took turns smoking a peace pipe. Then the formal time was over. Everyone went into the White House drawing room for wine and cake.

By then, the Plains Indian men could no longer stand to wear their tight-fitting white-men's clothes. They pulled off their boots and unbuttoned their coats. Soon, the president declared the meeting over.

The Red Dress

Some time after that last White House meeting,

Eagle of Delight received a very fine red or red-orange dress with tiny gold designs on it. Red was a special and important color among many Plains Indian tribes, so a red dress must have seemed very special to her.

That dress may have been made of cloth or silk or finely woven wool. It was called a stuff robe, and it was in style at that time. She may have worn it over her red pantaloons and her green coat or with a new white fur shawl from the president.

Eagle of Delight was delighted with her new red dress. She wore it often during her remaining time in the East. She even had her portrait painted several times wearing that red dress and white shawl.

Today, we can still see her portraits, so we know what she looked like. In that way, she will always be remembered wearing the clothes President Monroe gave her for being a delegate and an ambassador for her people.

Chapter 27
Picturing the Plains Indians

Thomas McKenney especially admired the 1821-1822 Native American visitors from the West, too. He thought they were fascinating. He was Superintendent of Indian Trade from 1816-1822. After that, he was in charge of the Bureau of Indian Affairs from 1824-1830.

McKenney saw that the Plains Indian way of life was changing. He was afraid native people would soon die out because of diseases, whiskey, war, and other things. He worked to help the Native Americans, but he knew he could not save them all. So he tried to preserve their culture.

He loved to collect their stories and artifacts. He put the artifacts on public display in his Washington offices so other people could see them, but he had no way to take photos of the Native American visitors.

Cameras had not been invented yet. The only way to make a picture of a person at that time was to sketch or paint them, or to draw a silhouette (black outline or shadow picture) of them, such as the one below. That one was done in 1805. Such silhouettes were good but left out many details.

Pagesgatse (Pag-us-got-suh) (Silhouette), by Charles Willson Peale, 1805. (*Courtesy, National Anthropological Archives, Smithsonian Institution, [Item MS 7129, INV 08682500]*) This silhouette portrait of Pagesgatse, a Pawnee boy who visited the East in 1805, was drawn from life by Charles Willson Peale who had an art and history museum in Philadelphia. Peale was the father of Titian Ramsey Peale, an artist who visited the Pawnee and Otoe villages with the 1819-1820 Stephen Long Expedition.

McKenney's Big Idea

Thomas McKenney had an idea. He decided that he needed to have portraits painted of the Plains Indians who were visiting Washington, D.C. In that way, future generations would always know what those early Native Americans looked like, what they wore, and who they were.

For that reason, McKenney asked the men in Congress to grant him some money. He wanted to pay an artist to paint portraits of at least eight of the seventeen Plains Indian delegates who were visiting the East in 1821-1822.

McKenney must have made a strong argument. Congress agreed to pay McKenney's young but talented artist friend Charles Bird King to draw and paint those pictures.

The Story of the Artist

McKenney's artist friend, Charles Bird King, was born in the East, in Rhode Island. His father was an American army officer during America's Revolutionary War in the late 1770s and early 1780s. After the war, the family went west to Ohio to find land. Ohio was a wilderness, at that time.

Charles was only four when his father was killed there by hostile Native Americans. He and his mother then moved back to live with his grandmother. There, a neighbor taught the boy to paint. Later, King went to New York and Europe to study painting with several famous artists.[70]

King learned his trade well. He returned to America and became very popular for painting portraits of famous Eastern people. With Thomas McKenney's help, King also became famous for painting many portraits of Native American visitors.

Painting the Delegates

King's first native portraits featured eight of the Plains Indian delegates of 1821-1822. He may have been the first artist to paint a portrait of a Plains Indian woman. That woman was Eagle of Delight in her red dress and white shawl. King also painted a portrait of Prairie Wolf, Eagle of Delight's husband, with his very unusual headdress of horns and tassels.

King painted portraits of the following delegates, as well: Petalesharo of the Skidi Pawnee, with his eagle feather headdress; Choncape (or Big Kansa) of the Otoe; White Plume or Monchousia

(Mon-chow-see-uh) of the Kansa; Big Elk or Ongpatonga (Ong-puh-tong-guh) of the Omaha; Sharitarish (Share-uh-tare-ish), the Grand Pawnee; and Peskelechaco (Pes-kuh-luh-chalk-co) of the Republican Pawnee; and possibly others.

The original paintings measured 17 inches by 14 inches. They were painted on wood panels instead of cloth or canvas. King received about $20 from the government for each portrait.

The original paintings were put aside for Thomas McKenney to display in his Indian Gallery office for people to see. Each of those eight portraits was also hand-traced and painted at least twice more.

Other Copies of the Portraits

A second set of eight hand-made copies (possibly on canvas or paper) was also put aside so that the person in the painting could take his or her portrait back home to the village. The government also paid for those.

A third set of the eight original portraits was hand-copied and kept by King. That set was part of his own personal collection. He displayed those works, and used them as models when he made and

sold copies to other people.

Some of those copies were full size. Others were smaller, only about 10 by 12 inches. Copies were painted on wood panels or on canvas or paper.

Eagle of Delight and the young Skidi Pawnee chief Petalesharo were the two most popular delegates at that time.[71] Their portraits may have been hand-copied the most, and at different times, perhaps even after they left the East and returned home. That explains why the copies do not all look exactly alike.

McKenney's Indian Gallery

The painting of those first eight delegates established a pattern. Over the next 20 years, the government paid King and other artists to paint the portraits of about 150 Native American visitors and delegates from twenty different tribes.

What Happened to the Portraits?

During the 1820s, McKenney kept copies of the original 1821-1822 portraits and others in his Indian Gallery office. Later, those and the rest of the 150 or so Native American portraits were sent to the Smithsonian Museum's Castle building. There they

were stored and displayed for anyone to see.

Those portraits were there in the late 1860s when a fire destroyed them and much of the Castle building. Today the Smithsonian's American Art Museum has some other copies of King's Native American portraits—including two small copies of the 1822 paintings. One of those is Eagle of Delight (listed as *Little Eagle, "Wad-ben-da-ba"*). The other is Petalesharo (listed as *Petelesharro, Generous Chief*).[72]

Other copies of King's portraits were also made and kept in museums, galleries, stores, and public or private homes or businesses. In that way, the people of the East could see the portraits, even if they could not see those people in person.

Copies to Other Countries

In the late 1820s and early 1830s, a few copies of some of those paintings were even given to delegates from foreign countries to take home with them. At least one set of five of the eight 1822 portraits went to the Netherlands (or Holland) in Europe in 1826. A different set of portraits went to a museum in Copenhagen, Denmark a few years later.[73]

Chapter 28
End of the Trail

Charles Bird King painted the first eight portraits of those 1821-1822 Native American delegates in February 1822.

By that time, the Indian agents were very worried. They knew that when the weather began to get warmer and more humid, the chances for disease increased. And the Native Americans had no natural resistance to most of those diseases.

In late February, the agents decided the delegates needed to start home right away, before the flu and cold season started. By then, the 1821 Plains Indian delegates had been gone so long that many of their people back home feared they were already dead.

Major O'Fallon, the Indian agent, had sold his wagons, horses, and mules when he first reached

Washington D.C., so he hired public coaches to take the delegates home. He also had six big boxes—or 1,700 pounds—of portraits, clothes, and other gifts that the delegates had received from the president and other people in the East.[74] Those things also had to go home with the delegates.

When everything was ready, the delegates climbed into the wagons and waved good-bye to their new friends in the East. They probably never saw any of those people again.

The government had spent $6,085 to impress the Plains Indians with the strength and power of the American people. But the people of the East were even more impressed with Eagle of Delight and the men of that Plains Indian delegation.

Return to the West

In early April, the delegates returned to St. Louis. They may have visited William Clark again. Then they went upriver by boat, before returning by horse to their villages.

At first sight, their friends and families were afraid of them. The delegates had been gone so long that their people feared they might be ghosts. When

their families saw they were still alive, the delegates were greeted with open arms. Then they were asked to tell and retell the story of their long journey.

Eagle of Delight had been an excellent representative for her people during the visit east. She had honored her husband, by always behaving respectably, and by showing she was a good, kind, intelligent woman—worthy of the Otoe mark of honor. She had made many friends, and had been very popular everywhere she went.

No one could have represented her people better. She had no reason to feel anything but proud, happy, and excited to be returning to her people—but she may also have been feeling a bit sick at that time.

Sad News From the West

Major O'Fallon reported to the government that all his Plains Indian delegates arrived home safely in the spring of 1822. But before long, someone in the East received very sad news. That news said Eagle of Delight had died shortly after returning home.

On the back of one of her portraits in the East, someone wrote that Eagle of Delight had died of measles, soon after arriving home at her village.[75]

Measles was called a "childhood disease" but it was often deadly to the Plains Indians who had no natural immunity to it.

Mourning for Eagle

Eagle of Delight's husband Prairie Wolf was almost destroyed by his young wife's death. He mourned for her so much that he almost died, too. He refused to eat and began drinking too much of the white traders' whiskey.

He forgot what was expected of a chief—he forgot to take care of himself or his family. He argued with his younger brother Big Blue Eyes. They fought often, and one day Big Blue Eyes was killed.[76]

Prairie Wolf could have stayed with his own people, but he became so sad and embarrassed that he left home. He went to live with the more war-like Pawnees. There, he tried to lose himself in battle against their common enemies. He fought very bravely and earned many more honors.

After a while, his Otoe friends came looking for him. They begged him to come home. They reminded him of his duty to his family and his people—a duty to go on doing good things. His people needed him.

Return to the Otoe

Eagle of Delight would have wanted her husband to go on living. She would have wanted him to represent their people well, just as she had always done. Prairie Wolf knew that. Finally, he returned to his family, his tribe, and his duties.

Later, he became a very respected head-chief at Yutan Village—the Otoe village that was named for him, the village where his wife was probably born.

But Prairie Wolf would never forget his beloved Eagle of Delight and their time in the East. Many years later, he still wore his blue army coat with one or two tassels on the shoulders. He also had a new fifth wife that some people called Eagle of Delight.

He had another copy of Eagle of Delight's portrait, too. That one was a gift from an Iowa chief named Mahaskah (Muh-hos-kuh) or White Cloud the Younger, who had seen her portrait back East in the 1830s. Mahaskah's family had known Eagle of Delight, and he knew that Prairie Wolf had loved her. Mahaskah had asked the government for a copy of that painting to take back to his friend Prairie Wolf.[77]

Chapter 29
Inspiring Others

No one seems to know what happened to the portrait that Eagle of Delight took home to her village, or to the other one brought to Prairie Wolf by Mahaskah the Younger, the Otoe chief. Those portraits and all the others that went home with the delegates are probably nothing but dust now.

But those visits to the East, and the portraits of Eagle of Delight, Prairie Wolf, Petalesharo, and others that were painted by King, also inspired other Eastern and European writers and artists to come west. Many of those artists wanted to see the Plains Indians in their own lands before those native people were gone.

George Catlin

In 1830 a young Eastern artist named George Catlin was inspired by stories and artwork of the

plains delegates. He went to St. Louis. There he joined William Clark on another journey across the West to learn more about the Plains Indians. For the next eight or nine years, Catlin visited Plains Indian villages collecting information.

He also painted the portraits of as many Plains Indian people as he could. He painted so many of them that he often had to leave the portraits and his notes with Indian agents for safekeeping.[78] His portrait collection is a true treasure of history.

Karl Bodmer

A similar thing happened with a young artist named Karl Bodmer from Switzerland. In 1832, Bodmer came to America and went west with Prince Maximilian of Germany. At the home of one Indian agent, Bodmer saw some of Catlin's paintings. He was inspired by them. For two years, Bodmer visited Plains Indian villages and painted historic portraits of those people, just as Catlin was doing.[79]

Washington Irving's Nephew

During that same time, 21-year-old John Treat Irving, Jr., came west to meet the Plains Indians who had impressed the people of the East a decade before.

He was the nephew of Washington Irving, a famous author best known for writing the popular tale, *The Legend of Sleepy Hollow*.

Washington Irving had also written an article called "Traits of Indian Character" in 1819-1820—around the same time that Stephen Long met the Pawnee and Otoe people. In 1832, Irving also went west to meet the Pawnee and wrote a book about that. In 1833, Irving's nephew John Treat visited some of those same Pawnee and Otoe villages, including the village of Prairie Wolf (whom he called Iotan).

John Treat noted in his own books that Iotan or Prairie Wolf had five wives then.[80] He did not give the name of that fifth wife in 1833. But some people in the East just assumed that Eagle of Delight was still alive, even though reports said she had died in 1822 or 1823. Two years after Irving's visit, Prairie Wolf's Otoe tribe moved away from Yutan Village.

Portraits in Books

By the 1830s, Thomas McKenney had collected about 150 portraits of Native American delegates. Other artists then copied and reprinted many of those and other portraits as lithograph paintings.

Lithographs were pictures made by carving the lines of a picture into blocks of wood. The blocks were then dipped in or brushed with ink or paint, then stamped on paper, and hand-colored or hand-painted.

Between 1837 and 1844, McKenney and his friend James Hall paid publishers to put those lithograph pictures together in a three-volume set of books. That set was called *The McKenney-Hall Indian Portrait Gallery* (or *The McKenney and Hall History of the Indian Tribes of North America*).

That three-book set featured Indian Gallery lithograph portraits with information about each of those Native Americans. Those books became some of the best resources on Native American history at that time. They also became collectors' items and were reprinted many times.

One of Eight

Eagle of Delight was one of only eight Native American women to have her portrait included in the McKenney-Hall books, among the portraits of more than a hundred men. Her picture shows her in the red dress and white shawl given to her by President Monroe. Some of those portraits show her with a

very pale blue circle tattoo between her eyes.[81]

The Importance of Remembering

Eagle of Delight lived and died such a long time ago. It is no wonder that much of her story has been lost over time. Fortunately, her portrait was painted back then, and newspaper stories and books of that time told about her life. Those things were all that people had—to tell them who she was, what she looked like, and why she was important to her people and the people of the East.

If those records had not been kept, we might never have known anything about her. Even so, those things were forgotten over time, for a while. Luckily, all those resources were stored away where people could eventually find them and search through them for the facts and the stories—to bring that history back to light.

That is good, because things have changed greatly since Eagle of Delight's time. Even her people no longer live on the plains of Nebraska where she once lived and died.

Chapter 30

Moving Away From the Homeland

Eagle of Delight's Otoe-Missouria tribe no longer lives in the area of land near Yutan Village that had once been her home. In 1833, while John Treat Irving was visiting there, the Otoe signed a treaty. Two years later, the Otoe left Yutan village. In 1854, Nebraska became a territory. By 1855, the Otoe-Missouria were living on a reservation in southeast Nebraska and northeast Kansas.

During the 1870s and 1880s, many Plains Indian tribes, including the Otoe, began moving from their old lands to new reservations further south in what was then called "Indian Territory" or Oklahoma.

In 1881, the Otoe and Missouria people left Nebraska. They moved to their new Otoe-Missouria Reservation at Red Rock, Oklahoma, not far from the new Pawnee Reservation at Pawnee, Oklahoma.

The Wish List

Over the passing decades, Eagle of Delight, Prairie Wolf, and others of their delegation were forgotten by almost everyone but their own people.

Then one day in 1961, First Lady Jacqueline "Jackie" Kennedy (the wife of President John F. Kennedy) started a project. She wanted to redecorate the White House, and she had a committee of art people working with her. They wanted to put historic artworks and other items back in the White House.

One of her committee members was Vincent Price. Best known as a famous actor in scary horror movies, he was also an art expert. His committee made a wish list for the White House. The list included five of Charles Bird King's native portraits.

Back in the White House

Vincent Price heard that a set of Charles Bird King paintings was for sale. That set included the portraits of five 1822 delegates: Eagle of Delight; Prairie Wolf; Petalesharo of the Skidi Pawnee; the Grand Pawnee chief Sharitarish; and a Kansa chief named Monchousia. That set of portraits had gone to the Netherlands (Holland) in 1826. Vincent Price and

his committee wanted to bring those paintings back.

Price worked with businesses, such as the Sears Roebuck Company, to get the money to make the purchase. Sears raised $40,000 to help buy the paintings. In 1962, Sears employees presented that set to Jackie Kennedy as a gift to the White House and to the American people.[82]

Mrs. Kennedy was a charming representative of her own people. As First Lady, she accepted the portraits of Eagle of Delight and the four other 1822 delegates. She and the committee put them on the wall of the White House library.

Once again, Eagle of Delight and four other delegates were back in the White House—back where they had visited President Monroe 140 years before. Their portraits are still on the wall there.

Rememberers of A Different Kind

In the 1960s, historians Herman J. Viola, John C. Ewers, and others researched those portraits and found some of the old stories. Then they wrote their own books and articles about the portraits and the delegates. Without their work, we might never have known who Eagle of Delight and the others were.

EAGLE OF DELIGHT 140

President John F. Kennedy, Jacqueline Kennedy [and Others], photo by Robert Knudsen, 1961, The White House. (*Courtesy, John F. Kennedy Presidential Library and Museum. Boston, Item KN-C17155-A*)

First Lady Jacqueline ("Jackie") Kennedy (pink dress) was a charming and respected ambassador for the American people. In 1962, she redecorated the White house. She requested, received, and put the portraits of Eagle of Delight, Prairie Wolf, and three other Plains Indian chiefs on display in the White House library.

Chapter 31
Eagle of Delight's Place in History

Eagle of Delight had a very important place in history. She was not a chief. But she was a chief's wife—and a highly respected one. As such, she was like a first lady of her people.

Other Native American women would follow in her footsteps. Some would even become chiefs and council members for their people. Eagle of Delight would have been proud of those women who made trails of their own.

She would have been proud to have her own picture—one of only eight women, including Pocahontas—among about 140 Native American men's portraits, in the McKenney and Hall books.

She would have been pleased to see that a portrait of her husband, Prairie Wolf or Shaumonekusse, is now "a favorite" painting at

Joslyn Art Museum in Omaha—not far from where she, her husband, and their people once lived.[83]

On the White House Wall

Eagle of Delight would also have been very pleased to see the portraits of herself, her husband, and three fellow delegates on the library walls of the White House. They are there today, and they still represent the people of the plains—four men and one woman of that 1821-1822 Plains Indian Delegation.

Eagle of Delight's Portrait

But you do not have to visit the White House to see Eagle of Delight's face or her red dress or her mark of honor. Her portrait and many others can still be seen in art galleries and private collections across America and around the world.

You might even see those pictures in books, documentaries, videos, or movies, on the internet, or even on posters. You might see them in stories about Native Americans, the Great Plains, Presidents, or the White House. You never know when or where you will see a portrait of her or the others.

In some ways, portraits of Eagle of Delight—the Darling of Washington Society—are almost as

popular now, as she once was in the East and on the plains in the early 1820s.

Although many people know her face, only a few know any of her names, even her most famous name, Eagle of Delight. Even fewer know her life story—or as much of it as it is possible to know, after all these years.

Though her life was short, her story is truly remarkable and noteworthy. It is just as important as the story of Pocahontas, Sacagawea, or the LaFlesche sisters, or any other great American woman of history. Her portrait is also important, because of its many original copies and places of honor, and because it shows what she really looked like in 1822.

She was Eagle of Delight, a young Native American woman much wiser than her years, a respected ambassador for her people and America. What a wonderful place she made for herself in history—hers is a story worth remembering.

And now you know her face, some of her names, and her story too. Be a rememberer and share her story with others.

(Optional) Thinking Questions and Activities: About Eagle of Delight

1. As you read this book, make a possible list of some "winter counts" for Eagle of Delight.
2. What was a cradleboard, and how was it used?
3. Look at the Eagle Clan Name Chart. If you were a member, what might your name have been? Why?
4. How did Otoe-Missouria teachings compare with teachings done in churches and schools today?
5. How and why did Plains Indians paint the part in their hair red? What else is red in the book?
6. What did Otoe policemen do to look different?
7. Why did Plains Indians strike the post, and why did that mean they were telling the truth?
8. How and why was Eagle of Delight's tiny tattoo important to her tribe and to related tribes?
9. What was a bride price and how did it work?
10. Look up the word dowry. Compare the Native American bride price to a dowry?
11. When and why did some Native American tribes allow a man to have more than one wife?
12. Compare Eagle of Delight to Sacagawea. How were they similar? How were they different?
13. Research the New Madrid earthquake.
14. Research what territories and states were once a part of the Louisiana Territory. Map them.
15. Why did communication problems exist between cultures, and how did people try to solve them?
16. Why did the explorers and presidents want to know more about the Plains Indians?
17. How did Eagle of Delight show she was wise?
18. How did Eagle of Delight show respect for herself, her husband, her people, and Easterners?
19. Why was it acceptable for Eagle of Delight to

speak to President Monroe and other leaders?
20. How and why were peace medals important in those days? How do you know they were?
21. Compare the symbols on the two peace medals.
22. What did Eagle of Delight want the president to give to the sub-chiefs? Why?
23. What gift did Eagle of Delight want for herself? Why do you think she wanted that gift?
24. Why did the people of the East want to know more about Eagle of Delight and the chiefs?
25. Why did Eagle of Delight choose not to dance?
26. Why do you think Eagle of Delight was called "the Darling of Washington (D.C.) Society"?
27. Why were the paintings of Eagle of Delight (and other Native American delegates) important?
28. Why did so many Native Americans die of diseases that were common to white people?
29. Why do you think Eagle of Delight's journey was important in history?
30. Make a Winter Count of your own life.
31. Make a silhouette or a drawing of some famous person in history.
32. Compare silhouette artwork to other kinds of portraits (or photographs). How are they the same and different?
33. Make a list of the diseases mentioned in the book.
34. Look up one of the diseases in the book. Describe its symptoms and tell how it is treated today.
35. Research earthlodges or tipis as homes, or how riverboats moved.
36. Map several of the places discussed in the book.
37. Explore educational websites in the bibliography.
38. Share Eagle of Delight's story with other people.

Endnotes

[1] Horan, 46; "Indians at Washington," 54; Viola, *Diplomats,* 72, 76-77.

[2] Phyllis Stone, a Lakota elder told of winter counts at the Pawnee Arts Center, in Dannebrog, Nebraska, April 21, 2013. The Lakota (sometimes called Sioux) are distantly related to the Otoe, Missouria, etc.

[3] Edmunds, 1-3, 6; Foster, 6, 40-41; Hamilton, iv-vi; Walters, 157-158; Whitman, xi.

[4] Edmunds, 1.

[5] Dickey, 13; Edmunds, 2; Foster, 40; *Otoe-Missouria*; Whitman, xi.

[6] Edmunds, 9; Whitman, 50, 51, 53.

[7] Edmunds, 2; Foster, 40; *Otoe Missouria Tribe*, Whitman, xi.

[8] Edmunds, 2; Foster, 40; *Otoe-Missouria Tribe.*

[9] *Otoe Missouria Tribe*, Walters, 158.

[10] Dickey, 37, 115.

[11] Whitman, 31, 72.

[12] Whitman, 65.

[13] Whitman, 16.

[14] Edmunds, 60; Foster, 41-42; Whitman, 17.

[15] Whitman, 27.

[16] Eagle of Delight (Hayne Hudjihini) and Little Eagle (Wad-ben-de-ba) are titles on portraits of Eagle of Delight, but the Otoe form of those names does not contain the Otoe word Xra that means Eagle.

[17] Whitman, 27-28.

[18] Edmunds, 9; Whitman, 45-46, 53.

[19] McKenney and Hall, v 1, 156.

[20] Edmunds, 30-31.

[21] Foster, 1-2.

[22] Bell, 31; Foster, 1-2.

[23] Edmunds, 30-32; Ronda, 17-23; Walters, 158; Whitman, 14.

[24] Dickey, 114; Lewis and Clark (Coues), 65, 78.

[25] Dickey, 115, 116; Ronda, 17-20.

[26] Edmunds, 32.

[27] Whitman, 48, 70

[28] Edmunds, 7-9; Howard, 98.

[29] Whitman, 80-81.

[30] Whitman, 80-81.

[31] Edmunds, 7-9; Whitman, 38, 42-43, 48-50, 69-72, 80-81.

[32] Bagnall, 41, 52.

[33] Edmunds, 36-37. Thwaites, v XV, 158-159.

[34] Foster, 8; Howard 61, 113; Skinner, 220-221, 241, 264-265, 268-270.

[35] Skinner, 241.

[36] Awakuni, 12-16, 30; Skinner, 241; Whitman, 70-80; Wolferman, 14.

[37] McKenney-Hall v 1, 306; Skinner, 268.

[38] Fletcher and LaFlesche, v2 503-509; Skinner, 222, 265, 269; Whitman, 78.

[39] Whitman, 76.

[40] Benson, 336-7.

[41] Benson, 110-113; James, 235; Whitman, 36.

[42] Benson, 110-111; McKenney-Hall, v 1, 158.
[43] Ewers, 45.
[44] Edmunds, 37; Ewers, 45.
[45] Edmunds, 37; Whitman, 63.
[46] Whitman, 50.
[47] Whitman, 50-55.
[48] Whitman, 50-55.
[49] Whitman, 52.
[50] Viola, "Invitation to Washington," 20.
[51] Viola, *Indian Legacy* 23.
[52] Dickey, 133: Walters, 157-158.
[53] Davidson and Lytle, v 1, 131, 134; Ewers, 45.
[54] Wolferman, 14.
[55] Horan, 46; "Indians at Washington," 54; Viola, *Diplomats,* 72, 76-77.
[56] Viola, *Diplomats,* 72.
[57] Edmunds, 34; Viola, *Indian Legacy of Charles Bird King,* 24-25, 69.
[58] *Niles' Weekly Register,* 245.
[59] Viola, *Indian Legacy,* 24-25; Viola, "Invitation," 22.
[60] Viola, *Indian Legacy, 24-25*; Viola, "Invitation," 22.
[61] Viola, *Indian Legacy,* 30; Viola, "Invitation," 28.
[62] Viola, *Diplomats,* 76-77; Viola, *Indian Legacy,* 32.
[63] Faux, v 2, 53.
[64] Davidson & Lytle, v 1, 133; Edmunds, 38-39; Horan, 296; "Indians at Washington," 54: Viola, *Diplomats,* 76-77; Viola, "Invitation," 22.
[65] Faux, v 2, 48-52; Viola, *Diplomats,* 145.
[66] Viola, *Diplomats,* 77.
[67] Viola, "Invitation," 22.
[68] Viola, *Indian Legacy,* 28.
[69] Davidson and Lytle, v 1, 133; "Indians at Washington," 54.
[70] Cosentino, 11-12; Ewers, 40, 45; Moore; Viola, *Indian Legacy,* 15.
[71] Viola, *Indian Legacy,* 34, 35, 41.
[72] Jean Lukesh saw the Little Eagle and Petaleshar[r]o paintings in the Smithsonian's American Art Museum archives in the 1990s.
[73] Viola, *Indian Legacy,* 119.
[74] Faux, v 2, 51; Horan, 296; Viola, *Indian Legacy,* 43.
[75] Cosentino 169; Edmunds, 38, 39; Ewers *Artists,* 45; Viola, *Diplomats,* 76-77; Viola, *Indian Legacy,* 43; Viola "Invitation," 31.
[76] Edmunds, 38; McKenney, v 1, 156-164.
[77] McKenney, v 1, 306; Viola, *Diplomats,* 120.
[78] Ewers; Moore.
[79] Ewers: Moore.
[80] Irving, 103.
[81] Viola, *Indian Legacy,* 34, 35; McKenney-Hall, v 1, 306.
[82] *Art in the White House,* 84-87, 326; Bradford, 183; Price, 285-288.
[83] Beal and others, 32-33.

Bibliography
Nonfiction:

Art in the White House: A Nation's Pride. Washington, D.C.: White House Historical Association, 1992.

Awakuni-Swetland, Mark. *Dance Lodges of the Omaha People: Building from Memory*. Lincoln: University of Nebraska Press, 2008.

Bagnall, Norma Hayes. *On Shaky Ground: The New Madrid Earthquakes of 1811-1812*. Columbia, MO: University of Missouri, 1996.

Beal, Graham W. J. and others. *Fifty Favorites from Joslyn Art Museum*. Omaha, Nebraska: Joslyn Art Museum, 1994.

Bell, John R. Ed. *The Journal of Captain John R. Bell*. Reprinted in Harlin M. Fuller and LeRoy R. Hafen's *Far West and Rockies* Series, vol. VI. Glendale, CA: Arthur H. Clark Co., 1973.

Benson, Maxine, Ed. *From Pittsburgh to the Rocky Mountains: Major Stephen Long's Expedition, 1819-1820*. Golden, CO: Fulcrum, 1988.

Bradford, Sarah. *America's Queen: The Life of Jacqueline Kennedy Onassis*. New York: Viking, 2000.

Cosentino, Andrew F. *The Paintings of Charles Bird King* (1785-1862). Washington, D.C.: Smithsonian, 1977.

Davidson, James West and Mark Hamilton Lytle. *After the Fact: The Art of Historical Detection*, vol. 1. New York: Knopf, 1982.

Dickey, Michael E. *The People of the River's Mouth: In Search of the Missouria Indians*. Columbia, MO: University of Missouri, 2011.

Edmunds, R. David. *The Otoe-Missouria People*. Phoenix, AZ: Indian Tribal Series, 1976.

Ewers, John C. *Artists of the Old West*. Garden City: Doubleday, 1965.

Faux, W. *Faux's Memorable Days in America, Nov. 27, 1818-July 21, 1820*. vol. 2. London: 1823, pp. 48-52. Reprinted in Thwaites, Reuben Gold. *Early Western Travels, 1748-1846*. vol. 5. Cleveland: Arthur H. Clark, 1905.

Fletcher, Alice C. and Francis LaFlesche. *The Omaha Tribe*. 2 vols. Lincoln, NE: University of Nebraska, Bison Books, 1992.

Foster, Lance. *The Indians of Iowa*. Iowa City, IA: University of Iowa Press, 2009.

Hamilton, William and Irvin, Samuel McLeary. *An Ioway Grammar: Illustrating the Principles of the Language Used by the Ioway, Otoe and Missouri Indians*. N.p.: Ioway and Sac Mission Press, 1848. Nabu Public Domain Reprints.

Horan, James D. *McKenney-Hall Portrait Gallery of American Indians*. New York: Crown, 1972.

Howard, James H. *The Ponca Tribe*. Lincoln: University of Nebraska Press, 1995. Reprinted from the Smithsonian Institution's Bureau of American Ethnology Bulletin 195, 1965.

"Indians at Washington," *Miscellanies Selected From the Public Journals*, vol. 2. Boston: Buckingham, 1824. Reprinted: Nabu Public Domain Reprints. (pp. 50-56).

Irving, John Treat, Jr. *Indian Sketches: Taken During an Expedition to the Pawnee Tribes in 1833*, in 2 volumes. 1835. Reprint.

Irving, Washington. *A Tour on the Prairies*. Norman: University of Oklahoma Press, 1956.

James, Edwin. *James's Account of S.H. Long's Expedition*, vol. 1. Cleveland, Ohio: Arthur H. Clark Co., 1905. Reprinted by Applewood Books, Carlisle, Massachusetts, no date.

Lewis, Meriwether and William Clark. *History of the Lewis and Clark Expedition*. Ed. by Elliott Coues. v 1 of 3 vols. New York: Dover, 1964.

McKenney, Thomas Lorraine and James Hall. *The Indian Tribes of North America with Biographical Sketches and Anecdotes of the Principal Chiefs.* Ed. by Frederick Webb Hodge. v 1 of 3 Vols. Edinburgh: John Grant, 1933.

Moore, Robert J., Jr. *Native Americans: A Portrait: The Art and Travels of Charles Bird King, George Catlin, and Karl Bodmer.* New York: Stewart, Taboir, and Chang, 1997.

Niles' Weekly Register, v 21. Baltimore: Niles, 1821-1822. Nabu Public Domain Reprint.

North American Indian Portfolios from the Library of Congress (Bodmer, Catlin, McKenney & Hall). New York: Abbeville, 1993.

Otoe-Missouria Tribe, www.omtribe.org/

Price, Victoria. *Vincent Price: A Daughter's Biography.* New York: St. Martin's Press, 1999.

Ronda, James P. *Lewis and Clark Among the Indians.* Lincoln: University of Nebraska Press, 1984.

Skinner, Alanson. *Ethnology of the Ioway Indians.* Bulletin of the Public Museum of the City of Milwaukee, v 5, no. 4, June 12, 1926. Reprinted. Milwaukee, WI: Aetna Press, n.d.

Stone, Phyllis. Lakota Woman's Talk. Pawnee Arts Center, Dannebrog, NE. April 21, 2013.

Viola, Herman J. *Diplomats in Buckskin A History of Indian Delegations in Washington City.* Washington, D.C.: Smithsonian, 1981.

Viola, Herman J. *Indian Legacy of Charles Bird King.* Washington, D.C.: Smithsonian, 1976.

Viola, Herman J. "Invitation to Washington—A Bid for Peace," *The American West.* January 1972. vol. IX, no. 1, pp. 18-31.

Walters, Anna Lee. *Talking Indian: Reflections on Survival and Writing.* Ithaca, NY: Firebrand Books, 1992.

Whitman, William. *The Oto.* New York: AMS Press, 1969. Reprinted from Columbia University Press, 1937.

Wolferman, Kristie C. *The Osage in Missouri.* Columbia, MO: University of Missouri Press, 1997.

Additional Educational Materials

Art in the White House: For Kids at
www.whitehousehistory.org/whha_tours/whitehouse_art/index.html.

Emergence of the Historic Tribes: The Oto and Missouria Tribe from the Nebraska State Historical Society's NebraskaStudies.org site, lessons and more at www.nebraskastudies.org/0300/frameset_reset.html?
www.nebraskastudies.org/0300/stories/0301_0106_1.html.

Fort Atkinson. www.fortatkinsononline.org/FortAtkinsonahistory.htm

Nebraska History.
www.nebraskahistory.org/archeo/pubs/Engineer%20Cantonment.pdf

Nebraska Timeline.
http://www.nebraskahistory.org/publish/publicat/timeline/index.shtml

Nebraska Trailblazer (See list of clickable links to Native Americans, Nebraska's First Farmers, Early Explorers, Early Settlers, Fort Atkinson, and lots more links to download information and activities at
http://www.nebraskahistory.org/museum/teachers/material/trailist.shtml

"Steamboats 1811-61: Western Engineer," The Steamboat Times. http://Steamboats.com/steamboats_1811~61_p1.html

Additional Historical Fiction/Picture Book:

Simmons, Clara Ann. *Sauncey and Mr. King's Gallery.* Schiffer, 1997, 30 pages.

Glossary and Index

Adams, John Quincy—Secretary of State, 6th President of the United States, 100.
ambassador—(See also representative); a person who represents a group or a country, 84, 104, 109, 117, 119, 140, 143.
ancestor—a parent or other older relative from the past, 6.
annual—something that happens once a year or every year.
Arapaho (Arapahoe)—a Western nomadic Plains Indian tribe, 16.
army coats, 112, 120, 131.
artifacts—weapons, tools; things made and used by a group of people, 112, 120.
Atkinson, Colonel Henry—builder and first commander of Nebraska's Fort Atkinson, 43, 45, 46, 49, 54, 69, 70.
Atkinson, Fort (See Fort Atkinson).
August—the month the Otoe called "the moon when the elk whistle," 33.
Baltimore—city in Maryland, 97.
Barber, Jonathan—Washington D.C. doctor friend of Eagle of Delight, 106..
Bellevue—once a fur trade post, now a city next to Omaha, Nebraska, 45.
"Beloved Child"—Otoe name given to a much-loved or a first-born child, 17.
Big Axe (or Big Ox)—Otoe-Missouria leader or warrior, 33.
Big Blue Eyes (or Great Big Blue Eyes or Very Big Eyes)—Otoe leader or warrior; Prairie Wolf's younger brother, 33, 130.
Big Elk (or Ongpatonga)— Omaha chief; 1821-1822 delegate, 124.
Big Horse—Otoe-Missouria headchief, also called Shunka-Tonka, Shongo-Tonga, Shonga-Tonga, Shunatonka, or Chongatonga, 33, 52, 53, 74.
Big Kansa (Big Kaw, or Big Konsa) (See Choncape).
birth of a child, 4, 17, 18, 20, 21, 27.
birth order, 20, 21, 22.
Black Cat—Missouria leader or warrior, 33.
bluff—a high, flat-topped hill, 32, 33, 45, 46, 47, 50, 51, 52, 68.
Bodmer, Karl (Carl)—artist who traveled with Prince Maximilian, 133.
Bonaparte, Napoleon—leader of France who sold Thomas Jefferson the Louisiana Territory in 1803, 27.
Brave Man—Otoe-Missouria leader or warrior, 33.
breechcloth—a narrow cloth worn between the legs of a Native American man and often tied around his waist with a leather string, 101.
bride price—honorable way to buy a wife in the 1800s, 64-66.
Brown, Jesse—owner of the Indian Queen Hotel in Washington D.C., 95.
buffalo (bison)—meat animal hunted on the early plains, 6, 15, 19, 31-33, 38, 101.
Bureau of Indian Affairs—government agency in charge of Native Americans, 120.
Calhoun, John C.—President Monroe's Secretary of War, 100.
Canada, 6, 8, 27, 70.
cantonment—military camp, 45, 46.
Cantonment Missouri—camp on the Missouri River near Fort Atkinson, 45, 46.
Catlin, George—artist, 132-133.
Central Plains, 71.
ceremony, 20, 41, 53, 56-59, 109.
Cheyenne—a Western nomadic Plains Indian tribe, 16.
chicken pox—a childhood disease, 81.
chief (leader), 1, 2, 9, 12, 24, 33, 36, 39, 40, 50, 52, 53, 55, 56, 60, 62, 63, 67, 73, 74, 75, 77, 82-84, 86, 88, 89, 90, 93, 98, 99, 100, 101, 104, 105, 108, 111, 112, 113, 114, 115, 116, 117, 125, 126, 130, 131, 132, 138, 140, 141.
Chiefs' Dance Society (See also Night Dance Society)—Otoe society of honor, 55, 58, 109.

childbirth, 17-18.
childcare and childhood, 17-21, 24, 37-41, 67.
Chiwere (Chee-WEH-ray)—name for the language group of the Otoe, 10.
cholera—one of the deadly diseases, 76, 81.
Choncape (Chon-cop-ee, Shaun-cop-ee, Shon-cop-ee, or Chono-cop-ee)—minor chief of the Otoe; 1821-1822 delegate; also known as Big Kansa, Big Konza, Big Kaw, 74, 75, 86, 87, 115, 123.
Chonemonicase (Chon-uh-mon-uh-case-ee or Shon-uh-mon-uh-koos-see) (See Prairie Wolf)—one of many names for Prairie Wolf of the Otoe.
clan—family group, 18, 19-23, 24, 64.
clan animals—animals associated with Otoe family groups, 19-20.
Clark, William—Co-leader of Lewis and Clark Expedition in 1804-1806, later in charge of fur traders, agents, and Plains Indians in Upper Missouri River area, 1, 29-32, 33-36, 45, 46, 50-51, 77-78, 87, 92-94, 128, 133.
Comanche (Tribe), 62, 98, 100.
"The Comanche"—another name for Prairie Wolf of the Otoe. 12, 62.
Congress—the branch of U.S. government that makes the laws, 69, 98, 100, 122.
Copenhagen—capital city of the country of Denmark in Europe, 126.
council—meeting; group of advisors, 31-33, 43, 45, 46, 47, 50-53, 60, 62, 68, 141.
Council Bluff—flat hill on the Nebraska side of the Missouri River (near Fort Atkinson), where Lewis and Clark, and Stephen Long, met with Native American tribes (Not Council Bluffs, Iowa), 32, 33, 45-46, 47, 51, 52, 68.
Council Bluffs, Iowa—city on the Iowa or east side of the Missouri River, 32.
cradleboard—Native American baby carrier made of rawhide leather, 18.
Crow's Head—Missouria leader or warrior, 33.
culture—the way of life, customs, and traditions of a group of people, 5, 6, 22, 26, 41, 55, 57, 79, 80, 105, 109, 112, 120.
dance and dancing, 55, 58, 100, 101, 108-110.
"Darling of Washington (D.C.) Society," 2, 105, 106, 142.
delegate—a person who represents people in government, 84, 87, 89, 90, 91-97, 98-101, 106-108, 111, 119, 122, 123, 125, 126-129, 132-134, 138, 139, 142.
delegation—a group of representatives or ambassadors, 84, 88-89, 128, 138, 142.
Denmark, a country in Europe, 126.
diphtheria—one of the deadly diseases, 81.
diseases, 14, 36, 76, 81, 120, 127, 130.
dowry (dow-ree)—an 1800s white society "bride price" in which a bride (or her father) gave money, goods, or property to her husband after marriage, 65.
dress (woman's clothing), 103, 117, 118-119, 123, 135, 140, 142.
Eagle Clan—a kinship group within the Otoe tribe, 21-23.
Eagle of Delight—Otoe Indian woman; 1821-1822 delegate, also known as Hayne Hudjihini [Hay-nuh Hoo-djuh-hee-nee], Wad-ben-de-ba, or Little Eagle, pre-1, 1-2, 3-5, 6, 11, 12, 16, 17, 19, 20-22, 26-27, 33, 36, 37, 40, 41, 42-43, 46, 51, 53, 54, 55-57, 59, 63, 64, 65, 68, 74-76, 83-88, 91, 101-110, 113-115, 117, 118-119, 123, 125, 126, 128-132, 134-140, 141-143.
earthlodge—traditional dome-shaped house of many Plains farming tribes, made of center posts and tree branches covered with sod, 9, 15, 16, 17, 38, 59. 91.
earthquake—great shaking of the earth, 42.
The East—eastern United States, 2, 3, 29, 31, 35, 36, 49, 69-70, 73, 74, 75, 77, 81-85, 91, 94, 97-100, 102, 104-108, 116, 118-119, 121-123, 125, 126, 128-129, 131, 132, 133-134, 136, 143.
elders—older, respected people with special skills and knowledge of the old ways of the tribe or group, 5, 10, 24, 38, 40, 58.

employees—people who work for a company.
England—one of the countries in the Great Britain area of Europe, 29.
Engineer Cantonment—military camp on the Missouri River near Ft. Atkinson, 45.
Europe—a continent of many countries, 2, 70, 123, 126, 132.
Ewers, John C. (historian author), 139.
expedition—a scientific trip to explore new areas, 44, 50, 63, 68, 69, 72, 121.
farmers, farms, farm crops, or farming, 6, 7, 15, 16, 38, 69, 80-81, 92, 97.
"First Lady"—wife of a president, governor, etc., 138, 139, 140, 141.
fishermen or fishing, 7.
"flat water"—another name for the Platte River, 13, 142.
flu—an illness or disease, 127.
formidable—powerful, very strong, frightening, dangerous, worthy, 94.
Fort Atkinson—fur trade fort west of the Missouri River, 46, 47, 51, 70, 71.
Fort Lisa—Missouri River fur trade post in Nebraska run by Manuel Lisa, 45, 70.
fort, 32, 45-46, 47, 51, 54, 70, 71, 97.
four—important number in many Plains Indian cultures, 20, 57, 58.
France—a country in Europe, 27, 100.
The Fur Trade—business based on trapping, trading, buying, and selling furs in the Rocky Mountains and Central Plains, 13, 31, 33, 45, 46, 70-71, 77, 78.
gender—whether a person is a boy (son) or a girl (daughter), 20, 22.
Generous Chief (See Petalesharo), 99, 126.
George Miller's Tavern—Washington hotel where the delegates stayed, 94-95.
Germany—a country in Europe, 133.
Good Horse (Shongo Pi)—one of Choncape's many names, 74.
Grand Pawnee—one of the three bands of the Southband Pawnee, 90, 124, 138.
"Gray Snow People"—another name for the Iowa Tribe, 9.
Great Britain—island area of Europe; England, Scotland, and other countries, 100.
Great Lakes—big "finger-shaped" lakes between Canada and the U.S., 6-8, 70.
Great Plains—grassland area of North America, contains Dakotas, Nebraska, Kansas, Oklahoma, and parts of other states, 11, 14, 27, 89, 142.
Gulf of Mexico—area of water south of Texas, 27.
Hall, James—with Thomas McKenney, put together a 3-volume set of books on Native Americans, featuring Eagle of Delight and others, 135, 141.
Hayne Hudjihini (Hay-nuh Hoo-djuh-hee-nee) (See Eagle of Delight)—another name for Eagle of Delight.
headdress (See also warbonnet), 99, 101, 112, 123.
Ho-Chunk—another name for the Winnebago Tribe, 7.
Holland—old name for the Netherlands, a country in Europe, 126, 138.
Hospitality—Otoe-Missouria leader or warrior, 33.
hostile—unfriendly or enemy, 7, 14, 81, 123.
humid—damp and sticky, like on a hot summer day, 127.
hunters and gatherers—nomadic people, 6, 7, 16.
hunters or hunting, 6, 7, 9, 15, 16, 18, 24, 31, 32, 33, 38, 39, 67, 68, 76, 80.
Iatan (I-uh-tan) (also Ietan, Iotan, L'Ietan, and Yutan) (See Prairie Wolf).
illnesses (See Diseases, or the specific names of diseases).
immunity—resistance or natural protection from something, like disease, 127, 130.
Indian agent (such as Major O'Fallon), 50-51, 73, 77, 81, 87, 90, 127, 133.
"Indian Country" (Missouri Territory; Kansas and Nebraska Territories), 78.
Indian Gallery—McKenney's Native American portraits and office; 124, 125, 135.
Indian Queen Hotel—Jesse Brown's hotel in Washington D.C. where Major O'Fallon and his later delegates stayed, 95.
"Indian Territory" (Oklahoma), 137.

EAGLE OF DELIGHT 153

interpreter—translator, someone who translates what people say, 87, 91, 105, 106.
Iotan (See Prairie Wolf of the Otoe).
Iowa (Ioway) Tribe, 7, 9, 15, 33, 52, 53, 55, 131.
Iowa (state), 9, 15, 29, 32.
Iron Eyes—Otoe-Missouria leader or warrior, 33.
Irving, John Treat, Jr.—nephew of Washington Irving; historian, 133-134, 137.
Irving, Washington—author of *The Legend of Sleepy Hollow*, 133-134.
James, Edwin—journalist with the Stephen Long Expedition, 59.
Jefferson, Thomas—U.S. president in the early 1800s, 27, 29, 34, 35, 36, 50.
Jefferson Peace Medal, 34, 35.
Joslyn Art Museum, 141-142.
Kansa (or Konza or Kaw)—tribe of Plains Indians in northeast Kansas and southeast Nebraska, 15, 51, 74-75, 78, 88-90, 107, 123-124, 138.
Kansas—territory and state, 137.
Kaw—another name for the Kansa, Konsa, or Konza tribe.
Kennedy, Jacqueline—"First Lady" and wife of President John F Kennedy, pre-1, 138-140.
Kennedy, John F.—U.S. president, 1960-1963, 138, 140.
King, Charles Bird—artist, painted portraits of Eagle of Delight, her husband, and other Native American delegates, pre-1, 99, 102, 122-127, 132, 138.
Kinship—relationships and relationship terms, such as father, mother, etc., 25.
Konsa or Konza, or Kaw Tribe (See Kansa).
L'Ietan (See Prairie Wolf of the Otoe).
LaFlesche sisters—two sisters who were members of the Omaha tribe, 1, 143.
Lakota—a nomadic Plains Indian tribal group, once called the Sioux, 16.
legend—a story based on a certain culture, history, or folklore, 9, 134.
The Legend of Sleepy Hollow—story by Washington Irving, 134.
Lewis, Meriwether—of the Lewis & Clark Expedition, 1, 29-32, 33-36, 45-46, 50.
Lewis and Clark—collective name for explorers Meriwether Lewis and William Clark, 1, 29-36, 45, 46, 50.
Lisa, Fort (See Fort Lisa).
Lisa, Manuel—fur trader at Fort Lisa on the Missouri River in Nebraska, 45.
lithograph (lithography)—artwork made from carvings and inks, 75, 134-135.
Little Eagle (or Wad-ben-da-ba), (See also Eagle of Delight), 21, 22, 126.
Little Thief, (See Voleur), 33, 36.
Long, Stephen—military explorer in the 1820s, 43-54, 59, 60, 62-64, 68, 69, 71, 72, 73, 121, 134.
Long's Dragon—another name for the modified steamboat *The Western Engineer*, designed by Stephen Long, 43-45, 47.
Long's Peak—Rocky Mountain peak named for Stephen Long, 72.
Loup—French word for wolf; another name for Skidi, Skeedee, or Wolf Pawnee; also the Loup River in Nebraska, where the Skidi often lived, 89.
Louisiana—a north of the Gulf of Mexico.
(The) Louisiana Purchase—large area of land in the central United States that was bought from France in 1803; or the buying of that land, 27, 28.
Louisiana Territory—another name for the land in the center part of the United States that was bought from France in 1803, 27-30, 50, 51, 78, 79.
Mahaskah the Younger—(White Cloud), young Iowa chief and friend of Prairie Wolf; sent a portrait of the late Eagle of Delight to Prairie Wolf, 131, 132.
Man Chief (See Petalesharo), 99, 101, 108.
Mark of Honor—(See also Tattoo), 40, 55, 56, 83, 84, 114, 129, 142.
marriage, 10, 41, 54, 63, 64-68, 74, 108.

Marshall, John—Supreme Court Chief Justice, 100.
Maximilian, Prince—a German prince who came to America to see the Plains Indians for himself. Artist Karl Bodmer traveled with him, 133.
McKenney, Thomas L.—Superintendent of Indian Affairs; decided the 1821 Plains Indian portraits should be painted, 75, 120, 122-125, 134, 135, 141.
McKenney and Hall History of the Indian Tribes of North America, 135.
McKenney-Hall Indian Portrait Gallery and litho paintings, 75, 135, 141.
measles—common childhood disease that was often deadly to Native Americans of any age in the 1800s, 76, 81, 129, 130.
Miller, George, owner of the Washington hotel where the delegates stayed, 94-95.
missionaries—people who go to teach other people about their religion, 78, 80.
Mississippi River, 27.
Missouri—a state; another name for the Missouria tribe or the Missouri River.
Missouri River, 9, 11, 12, 15, 29, 31, 32, 42-46, 47, 51, 63, 69, 77-78, 87.
Missouri Territory—later became the state of Missouri, 78.
Missouria Tribe—Plains Indian tribe often living with the Otoe, 7, 8, 9-11, 13-15, 17, 20, 24, 27, 31, 33, 34, 37, 45, 51, 52-55, 61, 74, 82, 84, 88-90, 107, 137.
modest—not pushy or showy.
Monchousia—White Plume, 1821-1822 Kansa delegate, 123-124, 138.
Monroe, James—U.S. president during Eagle of Delight's visit in 1821-1822, 36, 50, 69, 82, 84, 100, 111, 113, 116, 117, 119, 135, 139.
Monroe Peace Medal, 36, 113, 116, 117.
"Mother" or "Mother Earth"—names used by Native Americans to show respect for the earth, the land, and nature, 79.
museums—places where artifacts are kept, 2, 97, 121, 125, 126, 140, 142.
Names and naming, 1-2, 5, 6, 9, 10-11, 12, 13-14, 17-18, 19-23, 24-27, 31, 33, 36, 45, 46, 61-62, 72, 74, 79, 131.
Names of Honor—names given to a person for winning some honor; or a name given to honor another person, 24, 62, 74.
Napoleon (Bonaparte) of France—the leader of France in 1803, 27.
navy yards—places where military ships are made, kept, or repaired, 97.
Nebraska, 6, 8, 11, 12, 13, 15, 27, 29, 32, 45, 46, 52, 78, 136, 137, 142.
Nebraska State Historical Society, 12.
Ne-brath-ga or Ne-brath-ka—Nebraska; Otoe word meaning "flat water," 13, 142.
The Netherlands—another name for Holland, in Europe, 126, 138.
New Madrid (Missouri) Earthquake—series of severe earth shakings in the winter months of 1811-1812, with a center at New Madrid, Missouri, and extending in all directions across the United States, 42.
New Year's Day—January 1, 100, 105.
New York—both a state and a big city in that state, in the East, 97, 123.
newspapers, 94, 100, 107, 111, 118, 136.
nicknames—a name based on a special feature or quality of a person, 10, 24-25.
Night Dance Society—an Otoe honor society or group for chiefs, their wives, and daughters (sometimes called Chiefs' Society or Chiefs' Dance), 55, 58, 109.
nomadic—often moving to find food, not always living in the same place, 16.
O'Fallon, (Major) Benjamin—Indian agent for Upper Missouri River tribes; William Clark's nephew, 50-51, 60, 73, 77-78, 82, 87, 90, 92, 94, 95, 97, 100, 111, 127, 129.
O'Fallon, John—trader at Fort Atkinson; William Clark's nephew; older brother of Major Benjamin O'Fallon; trading partner of Manuel Lisa, 51.
Ohio—a state, 122.
Oklahoma—Southern Plains state once known as Indian Territory; where the Otoe-

Missouria, Pawnee, and many other Native American tribes moved, 137.
Omaha—largest city in Nebraska, along the Missouri River. 12, 141.
Omaha—Plains Indian farming tribe, 1, 14-15, 51, 55, 74, 78, 88, 89, 90, 107, 124.
Ongpatonga (Ong-puh-tong-guh) (See Big Elk), 124.
oral history—spoken history; a practice of memorizing and telling history stories aloud so they are passed on to future generations, 5.
Oto—another way to spell Otoe.
Oto (or Otoe) Council (Painting)—drawn and painted by artist Samuel Seymour of the Stephen Long Expedition, 51-53.
Otoe (pronounced O'-tō; sometimes written as Oto, Otoe-Missouria, or Oto-Missouri, or incorrectly as Otto or Ottoe)—Plains Indian tribe who lived in Nebraska with the Missouria, and now share a reservation in Oklahoma, 1-3, 5, 6-15, 17-26, 27, 31-38, 40-43, 45, 47, 50-56, 59-63, 65-68, 71, 74-75, 78-79, 82, 84, 86, 88, 89, 90, 93, 100-102, 107-108, 115, 121, 123, 129-131, 132, 134, 137.
Otoe-Missouria Reservation—government location for the Otoe and Missouria people; first reservation was in Nebraska, the current one is in Oklahoma, 137.
Otoe-Missouria Tribe—often just called the Otoe.
Pagesgatse (Pag-us-got-suh)—a Pawnee boy who visited the East in 1805 and had his silhouette portrait drawn there and put in a museum, 121.
pantaloons—a style of fancy pants, worn by women (as showy slips or underwear or pants) under their dresses in the 1800s, 103, 114, 117, 119.
Pawnee—tribe of Native Americans who lived in Nebraska and Kansas until moving to Oklahoma in the 1870s, 14, 15, 32, 45, 47, 51, 54, 71, 74, 78, 88-90, 93, 94, 98-101, 107, 108, 115, 121, 123, 124, 125, 130, 134, 137, 138.
Pawnee, Oklahoma—home town of the Pawnees' current Reservation, 137.
Pawnee Reservation—government location for the Pawnee nation; once in Nebraska, now in Oklahoma, 137.
peace medals—non-monetary coins given away by the government and army to show friendship, 34, 35, 36, 50, 101, 113, 115, 116, 117.
peace treaty—paper agreement signed by two groups, promising peace, 46, 137.
Peale, Charles Willson—Philadelphia artist and museum owner, 30, 93, 121.
Peale, Titan Ramsey—youngest son of Charles Willson Peale; an artist with the Stephen Long Expedition, 44, 72, 121.
Peskelechaco (Pes-kuh-luh-chalk-co)—Republican Pawnee chief, 1821-1822 delegate, 124.
Petalesharo (Peet-uh-luh-shar-o) (Also called Petalesharro, Man Chief, Generous Chief of the Skidi Pawnee), 93, 98-101, 108, 115, 123, 125, 126, 132, 138.
Petalesharro (See Petalesharo).
Philadelphia—big city in Pennsylvania, 44, 52, 97, 121.
Picotte, Susan LaFlesche—Omaha Indian woman, 1st Native American woman medical doctor; sister of Susette LaFlesche Tibbles, 1, 143.
plains—grasslands.
"platte"—French word meaning flat; gave its name to the Platte River, 13.
Platte River—major east-west river across Nebraska, 11, 13, 31, 71, 72, 142.
policeman (Otoe policemen were painted black and carried whips), 60, 61, 63, 64.
Pocahontas (Po-kuh-hon-tus), 1, 141, 143.
Ponca—a northeastern tribe in Nebraska; Standing Bear's tribe, 1, 15, 55.
portrait—a painting of a person, pre-1-2, 30, 93, 99, 102, 119, 121-129, 131-143.
prairie dog, 31.
Prairie Wolf—Eagle of Delight's husband; Otoe sub-chief; 1821-1822 Otoe delegate (also known as Shaumonekusse [Sha-mon-uh-koo-see], Chonemonicase [Chon-uh-mon-uh-case-ee], Ietan [I-uh-tan], Iatan, Iotan, L'Ietan [Lee-uh-tan],

or Yutan [Yoo-tan]), 12, 61-68, 74-77, 83, 101-102, 106, 108, 115, 117, 123, 130-132, 134, 138, 140, 141.
president, 2, 27, 29, 31, 34-36, 49, 50, 69, 71, 74, 76, 82, 84, 96-97, 100, 111-119, 128, 135, 138-140.
prey—to hunt or a person or animal that is hunted, 21.
Price, Vincent—artist, horror movie star, White House art expert 138, 139.
rawhide—tough thick leather 18.
Red Head's (or Red Hair's) Town—nickname for St. Louis, 92, 93, 94.
Red Rock, Oklahoma—name/location of the Otoe Missouria Reservation, 137.
rememberers—elders who tell their tribe's history through stories, 4-5
representative, 74, 82, 87, 114, 129, 139.
Republican Pawnee—a band of the Pawnee, (See also Southband Pawnee), 124.
resistance—ability to fight against something, such as disease; immunity, 127. 130.
resources—books and things used to find information.
Revolutionary War (American Revolution), 122.
Rhode Island, 122.
riverboats—another name for steamboats on the rivers, 42-44, 47-48, 69.
Rocky Mountains—tall mountains that run north and south through the Central U.S. from Canada to Mexico, 27, 70-72.
Russia—a very big country extending across Europe and Asia, 29, 100.
Sacagawea—Shoshone Indian woman who guided Lewis and Clark, 1, 36, 143.
Saint Louis, Missouri, (See St. Louis).
Sears Roebuck Company, 139.
Seymour, Samuel, 51, 52, 53.
Sharitarish (Share-uh-tare-ish)—Grand Pawnee Chief, 1821 delegate, 90, 124, 138.
Shaumonekusse (Shuh-mon-uh-koo-see) (See Prairie Wolf).
shawl—scarf, cape, or fur worn on the shoulders; sleeveless jacket, 119, 123, 135.
Shongo Pi (See Choncape).
Shongo Tonga (See Big Horse), 33, 53.
Shoshone (Show-show-nee)—Native American tribe from the Utah-Wyoming, 36.
silhouette (sil-oh-wet)—an outline portrait usually done in one color, 121.
Sioux, (former name for the Lakota), 16.
skeleton, 106-107.
Skidi (Skeedee, Wolf, or Loup Pawnee), 89, 93, 98-99, 101, 108, 123, 125, 138.
slaves, 95.
smallpox—one of the diseases that killed many people, 14, 76, 81.
Smith, John, 1.
Smithsonian Institute and Museums, 121, 125, 126.
society—group of people who share customs; a class level of people.
Southband Pawnee (Grand, Republican, and Pitahauerat Pawnee; not Skidi), 89
Spain, 29.
speeches, 35, 53, 112, 115, 118.
St. Louis, Missouri, 50, 70, 78, 85, 87, 91, 92-93, 94, 128, 133.
Standing Bear—Chief of the Ponca tribe, 1.
steamboats (See also riverboats), 42-45, 47, 48, 69.
"striking the post," 60-61.
stuff robe—stylish dress of the early 1800s, Eagle of Delight's red dress, 119.
Superintendent of Indian Trade—government official who made decisions for Native Americans, agents, and traders in the early 1800s, 120.
Sweden, 100.
Switzerland, 133.
tassel—colored threads hanging down from a cap or a patch, 101, 111, 123, 131.

tattoo—(See also Mark of Honor), 40, 55-59, 83, 84, 114, 129, 136, 142.
teachings, 38-40, 57, 79, 86.
Tennison's Inn—Hotel in Washington D.C., 95.
territory—area of land not yet a state, 27-30, 51, 78-79, 137.
The Thief or Little Thief, (See Voleur), 33, 36.
Tibbles, Susette LaFlesche—Omaha Indian woman, 1, 143.
tipi—a Central Plains spelling of the word teepee, 15, 16, 17, 38, 91.
traditional—according to a person's culture or customs.
traditional (Otoe) names, 21, 22, 23.
"Traits of Indian Character"—article written by Washington Irving, 134.
translator—interpreter, 87, 91, 105, 106.
U.S. Marine Corps Band, 100.
Upper Missouri River—northern part of the Missouri River, 51, 77, 87.
vermilion—a red mineral once used for face painting, 86.
Viola, Herman J., historian and author who wrote about the delegates, 139.
Virginia Colony, 1.
Voleur—Little Thief or The Thief, Otoe headchief in the early 1800s, 33, 36, 76.
Wad-ben-da-ba (or Little Eagle), (See Eagle of Delight), 126.
warbonnet (See also headdress)—feathers and more, worn on the head to symbolize a chief's earned honors and position in a tribe, 99, 101, 112, 123.
Washington D.C. (Washington, Washington City), 2, 73, 85, 90, 94, 96-98, 105-106, 120, 122, 128, 143.
The West, 49, 91, 120, 128, 129, 133.
The Western Engineer (See also Long's Dragon), 43-44.
whiskey, 120, 130.
White Horse—Otoe-Missouria leader or warrior, 33.
The White House—building where the U.S. president lives, pre-1-2, 97, 99, 100, 102, 105, 111, 118, 138, 139, 140, 142.
White Plume (also Monchousia)—Kansa chief; 1821-1822 delegate, 123-124, 138.
Winnebago Tribe (also known as the Ho-Chunk), 7, 55.
winter counts—keeping track of a person's life using one event to represent each year (can also be an actual count of the number of people still alive each year), 4.
Wirt, Laura—daughter of an important government official in the 1820s, 104.
Yutan (Yoo-tan) (another name for Prairie Wolf of the Otoe), 12, 62, 102.
Yutan, Nebraska—a Nebraska town, 12.
Yutan Village—Otoe-Missouria village in eastern Nebraska, near the present towns of Yutan and Wahoo. Named for Yutan or Prairie Wolf, an Otoe chief there in the 1820s and 1830s, 8, 11, 12, 13-14, 17, 53, 131, 134, 137.

Noteworthy Americans
Quick Reader Biography Series
by Dr. Jean A. Lukesh and
Field Mouse Productions:

Lucky Ears: The True Story of Ben Kuroki, World War II Hero, ©October 2010.
*2011 IPPY Children/Teens/Young Adults Multicultural Nonfiction (Bronze Medal) National Book Award
*2011 MOONBEAM Young Adult Multicultural Nonfiction (Bronze Medal) National Book Award

Sky Rider: The Story of Evelyn Sharp, World War II WASP (Women Air Force Service Pilots), ©December 2011.

Wolves in Blue: Stories of the North Brothers and Their Pawnee Scouts, ©December 2011.
*2012 BENJAMIN FRANKLIN Finalist Teen National Book Award
*2012 Western Writers of America SPUR Finalist, Best Western Juvenile Nonfiction National Book Award

Eagle of Delight: Portrait of the Plains Indian Girl in the White House, ©August 2013.

Bravest of the Brave: Petalesharo of the Skidi Pawnee, Hero of the Plains, Portrait in the White House, ©2014

Take a look at our good books at
www.fieldmousebooks.com
www.fieldmouseproductions.com

7 National Book Awards, 2 State Book Awards, and 4 other Author, Literacy, and Literary Awards

Field Mouse
PRODUCTIONS

About the Author

Jean A. Lukesh earned many honors and accolades while working as a school librarian and teacher for 30 years. During that time, she often gave booktalks, presentations, and workshops, all across the state, on writing, history, and other subjects. She worked with students, teachers, authors, editors, publishers, and even national museums; edited books for various small presses and other authors; started a small publishing company; wrote a multi-award-winning state history book for a traditional publisher, and collaborated on a local history book that won multiple book awards.

In 2006, she retired from teaching—to finish her doctorate and have more time for her horses, family, and writing. After that, she received several literary and literacy honors and awards, wrote six more books of her own, and received six more national/international book awards. She currently writes "The Nebraska Trivia Quiz" for *Nebraska Life Magazine*, writes occasional newspaper articles, mentors other writers, has several more books in progress—mostly nonfiction titles—and continues to give history and book presentations, as time allows.

Dr. Lukesh holds a Bachelors in Education, Magna Cum Laude, with several endorsements, a Masters in Education (English), a Master in Education (History), a Doctorate in Education (Curriculum and Instruction), and a certificate in publishing. And yes, history and literature are her favorite subjects.

"Most people tell me they never really liked history until they became an adult. And now they love it!

"That's because history is much more than just a bunch of dates to be memorized in school.

"History is a collection of real, true, human-interest stories of everyday people who did the best they could, to overcome obstacles, and to make a difference in the world. Those are the stories people want to know."
—Dr. Jean A. Lukesh

Who in the world was Eagle of Delight?

And why is her 1822 portrait in the White House today?

Why was that teenage Plains Indian girl called "The Darling of Washington (D.C.) Society" in 1821 and 1822?

What is her 1960s connection to "First Lady" Jackie Kennedy and horror movie star Vincent Price?

In 1821, Eagle of Delight, a teenage bride with "the mark of honor," traveled east more than 1,400 miles to talk with the president in the White House. There, she became "the Darling of Washington D.C. Society"—one of the most popular and famous Native American women in the world—perhaps as famous as Pocahontas or Sacagawea!

But soon tragedy struck, and over the next 140 years, she, her legacy, and her story were nearly forgotten. Then a series of remarkable events brought her portrait home to the White House and her noteworthy story back to light.

This **quick-reading true biography**, for **readers ages 10 to 110**, explores the mystery of *Eagle of Delight* and helps uncover and discover the history of the *Portrait of the Plains Indian Girl in the White House*.

Eagle of Delight: Portrait of the Plains Indian Girl in the White House is the fourth book in the **Noteworthy Americans Series of Quick-Reading Biographies**, for **readers ages 10 to 110**, by **Dr. Jean A. Lukesh**, author and winner of 7 **National Book Awards**, 2 **State Book Awards**, and 4 **Author, Literacy, and Literary Awards**.

Look at all the good reads we have in store for you at
www.fieldmousebooks.com www.fieldmouseproductions.com

Field Mouse
PRODUCTIONS